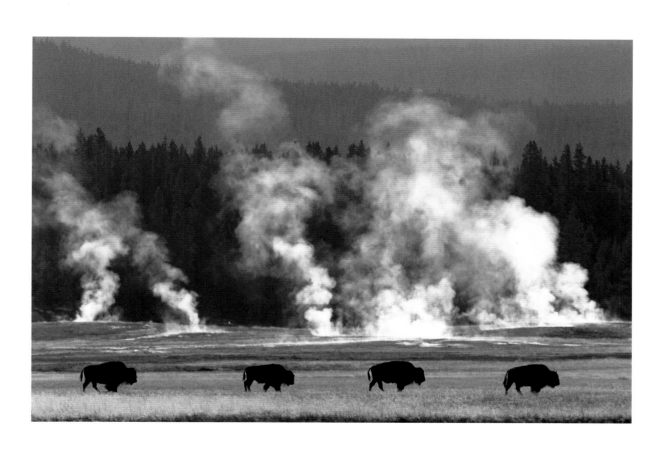

Wildlife Photographer of the Year

Portfolio 14

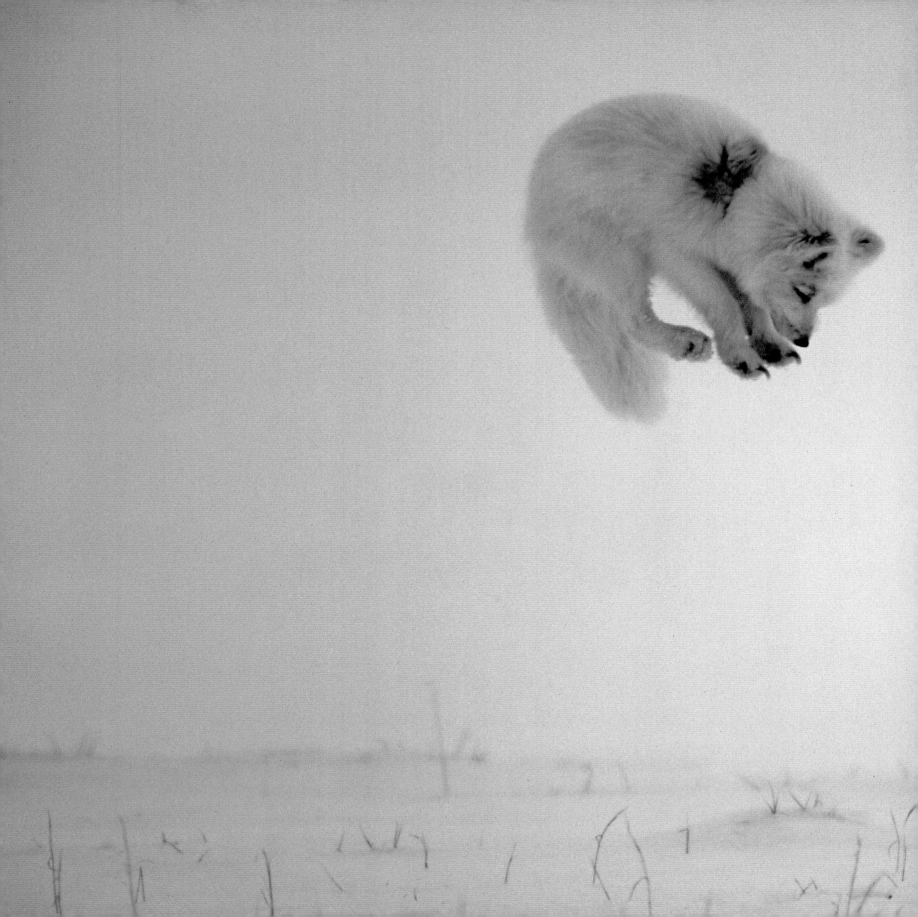

Wildlife Photographer of the Year

Portfolio 14

Publisher
BBC Worldwide Limited
Woodlands
80 Wood Lane
London W12 0TT

First published 2004

Managing editor
Rosamund Kidman Cox
Designer
Simon Bishop
Jacket designer
Pene Parker
Caption writers
Rachel Ashton
Tamsin Constable
Production controller
Christopher Tinker
Competition manager
Louise Grove-White
Competition officer
Gemma Webster

ISBN 0 563 52180 5

Printed and bound in Great Britain
by Butler and Tanner Limited,
Frome and London

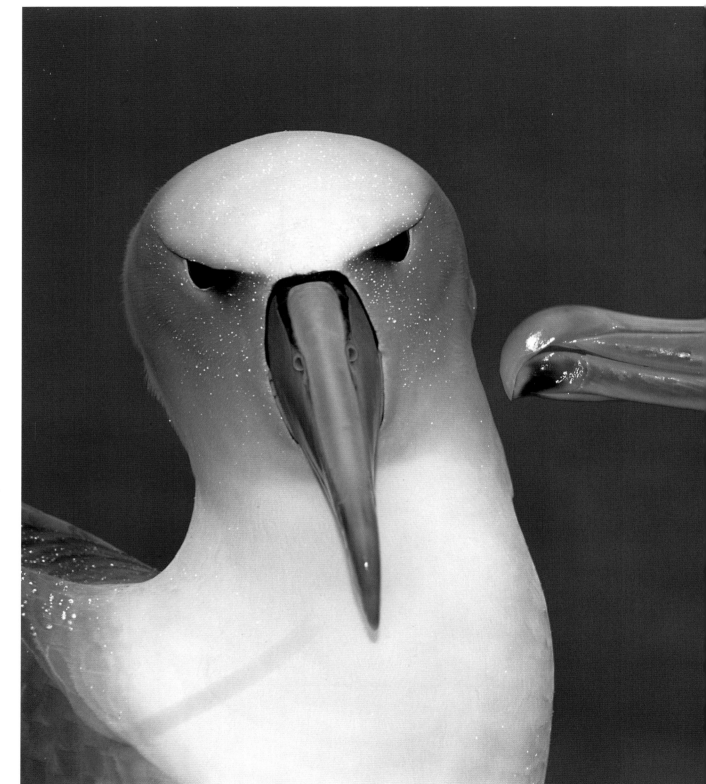

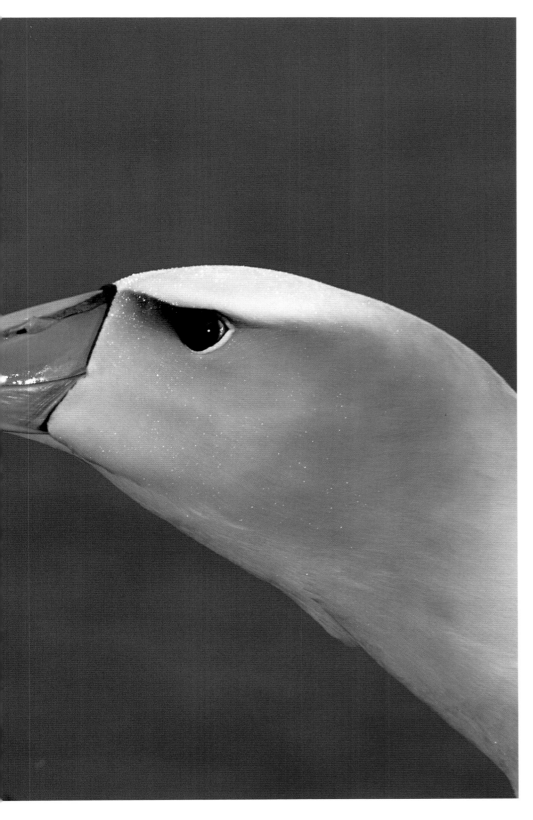

Contents

Foreword

by Chris Packham

Astonishing! That was the first word that came into my head when I held up the four wallets of dupes of the 90 photographs in this book. As my eyes ran quickly over the mosaic of species, spaces, colours and ideas, I shook my head, put them down, had another sip of tea and thought . . . astonishing. And I had seen all these pictures before. So it wasn't that gratuitous shock of novelty, not that 'wow' of an impulsive first impression. No, this was only a memory jog, a glance at some much studied images. And yet their impact was still undeniably profound. Also, I must assert that I dislike the wanton overuse and misuse of adjectives in this tabloid age, and so the 'A' word is one hundred per cent apt. Turn over and see for yourself.

But before you do, consider this. Try to imagine the collective time, the sum of all the photographers' days spent flying, driving and trekking to the locations, all those hours spent waiting for just a few fractions of a second. Try to conceive of all the thirst, hunger and discomfort, all the time away from loved ones, all the duties neglected or the divorces or disagreements fuelled by the pursuit of these photos. Think of the total currency spent to produce this album, all the drachmas, dollars, pounds and euros dispersed into the global economy by

these determined picture-makers. It's all so immeasurable, so impressive, but in truth, only the basic foundation of this remarkable catalogue.

You see, what is even more difficult to appreciate are all the lifetimes of experience, the skills honed, the subtle, subconscious or secret knowledges earned or shared, without which such photographs could never be made. Then be awed by the imaginations excited, the chances taken and the individual input of all the ingredients that give these pictures the winning touch, make them so special that they are sometimes singly, but without doubt collectively, astonishing.

Lastly, consider the subjects represented. In the main they are living and quite beyond the direction or control of the photographer. "Left a little, OK nice . . . now hold it!" has no more effect upon a shark than on a spider or a snake. These 'models' cannot be paid or made to turn up on time and perform. And perhaps worst of all for our lensmen and women, they simply will not "do that again please." No, these prize winners have been entertaining degrees of fantasy and frustration that photographers of other genres could never imagine or tolerate. And yet, when all the applause dies down, the satisfied smiles fade and this book is

shelved, how will they be regarded?

In my opinion, not as highly as they might, not out in the marketplace of mainstream photography, not up against the society snappers, the portrait pushers or the arty avant-garders. Even press photography seems to have recently been afforded the global kudos it has so long deserved: exhibitions by its masters decorate prominent galleries in London, Paris, New York, etc.

Of course this collection will tour widely. It acts as a great ambassador for its field of interest and for all the life it documents, but it's still playing at mainly provincial venues. What a travesty and what a shame.

The artistry here is undeniable, the skill so clearly apparent, the sheer beauty probably the principal ingredient that will radiate from these images and touch the viewers in such a dramatic and . . . well, you'll all have your own apt adjectives – so get them ready as you turn the pages.

PS A practical note and serious plea to photographers. For several years, the categories of Urban and garden wildlife and The world in our hands have been undersubscribed and underachieving. Is there any chance we might see a few more good photographs here?

The competition

This is a showcase for the very best photography worldwide featuring natural subjects. It is organised by two UK institutions that pride themselves on revealing and championing the diversity of life on Earth – the Natural History Museum and *BBC Wildlife Magazine*.

Its origins go back as far as 1964, when the magazine was called *Animals* and there were just three categories and about 600 entries.

It grew in stature over the years, and in 1984, *BBC Wildlife Magazine* and the Natural History Museum joined forces to create the competition as it is today, with the categories and awards you see in this book.

Now there are more than 20,500 entries, and exhibitions touring through the year, not only in the UK but also worldwide, from the US, the Caribbean and South Africa, through Europe and across to China, Japan and Australia. As a result, the photographs are now seen by millions of people.

The aims of the competition are
- to raise the status of wildlife photography into that of mainstream art;
- to be the world's most respected forum for wildlife photographic art, showcasing the very best photographic images of nature to a worldwide audience;
- to inspire a new generation of photographic artists to produce visionary and expressive interpretations of nature;
- to use its collection of inspirational photographs to make people, worldwide, wonder at the splendour, drama and variety of life on Earth.

The judges put aesthetic criteria above all others but at the same time place great emphasis on photographs taken in wild and free conditions, considering that the welfare of the subject is paramount.

Winning a prize in this competition is something that most wildlife photographers aspire to. Professionals do win many of the prizes, but amateurs succeed, too. And that's because achieving the perfect picture is down to a mixture of vision, luck and knowledge of nature, which doesn't necessarily require an armoury of equipment and global travel, as the pictures by young photographers so often emphasise.

Past award-winners

1991
Frans Lanting

1992 André Bärtschi

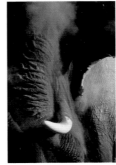

1993
Martyn Colbeck

1994 Thomas D Mangelsen

1995
Cherry Alexander

1996
Jason Venus

NATURAL HISTORY MUSEUM

Home to a world-class natural history collection, a leading scientific research institution and one of London's most beautiful landmarks, the Natural History Museum is also highly regarded for its pioneering approach to exhibitions, welcoming this year nearly three million visitors of all ages and levels of interest.

Wildlife Photographer of the Year is one of the museum's most successful and long-running special exhibitions, and we are proud to have helped make it the most prestigious competition of its kind in the world. The annual exhibition of award-winning images – now in its twenty-first year – attracts a large audience who come not only to admire the stunning images, but also to gain an insight into important global concerns such as conservation, pollution and biodiversity – issues at the heart of the museum's work.

In 2002, the museum opened Phase One of the Darwin Centre, a significant new development, which reveals for the first time the incredible range of our collections and the scientific research they support. Both the Darwin Centre and Wildlife Photographer of the Year celebrate the beauty and importance of the natural world and encourage visitors to see the environment around them with new eyes.

Further information
Visit www.nhm.ac.uk for further information about activities. You can also call +44 (0)20 7942 5000, email information@nhm.ac.uk or write to Information Enquiries, The Natural History Museum, Cromwell Road, London SW7 5BD.

Wildlife MAGAZINE

BBC Wildlife Magazine is the UK's leading monthly magazine on nature and the environment. It prides itself on world-class photography and the best and most informative writing of any consumer magazine in its field. The contents include photographic portfolios, the latest biological discoveries, insights, views and news on wildlife, conservation and environmental issues in the UK and worldwide and a monthly illustrated guide to natural history you can see for yourself.

The magazine's aim is to inspire readers with the sheer wonder of nature and highlight our dependence on it, and to present them with a view of the natural world that has relevance to their lives.

It has been an organiser of the competition since 1964, when it first began, publishing all the winning pictures and showcasing more work by the world's best photographers.

Further information
BBC Wildlife Magazine,
Origin Publishing,
14th Floor, Tower House,
Fairfax Street,
Bristol
BS1 3BN
wildlifemagazine@origin
publishing.co.uk

Subscriptions
Tel: +44 (0) 870 4447013
Fax: +44 (0) 870 4442565
wildlife@galleon.co.uk
Quote WLPF04 for the latest subscription offer.

Frances Abraham
Picture researcher

Richard du Toit
Wildlife photographer

Tony Heald
Wildlife photographer

Jennifer Jeffrey
Picture researcher

Rosamund Kidman Cox
Former editor, *BBC Wildlife Magazine*

Florian Möllers
Wildlife photographer

Chris Packham
Photographer and film-maker

Tim Parmenter
Head of the photographic unit,
the Natural History Museum

Nik Pollard
Wildlife artist

Jonathan Scott
Wildlife photographer and presenter

Pedro Silmon
Art director, *Tatler* magazine

Kirsten Sowry
Former picture editor, *BBC Wildlife Magazine*

Vickie Walters
Picture researcher

Zoe Whishaw
European director of photography,
Getty Images

1997
Tapani Räsänen

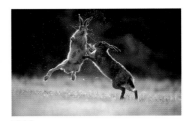

1998
Manfred Danegger

1999
Jamie Thom

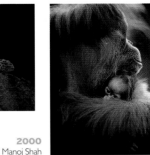

2000
Manoj Shah

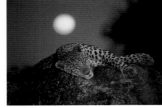

2001
Tobias Bernhard

2002
Angie Scott

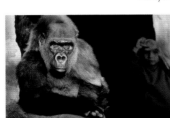

2003
Gerhard Schulz

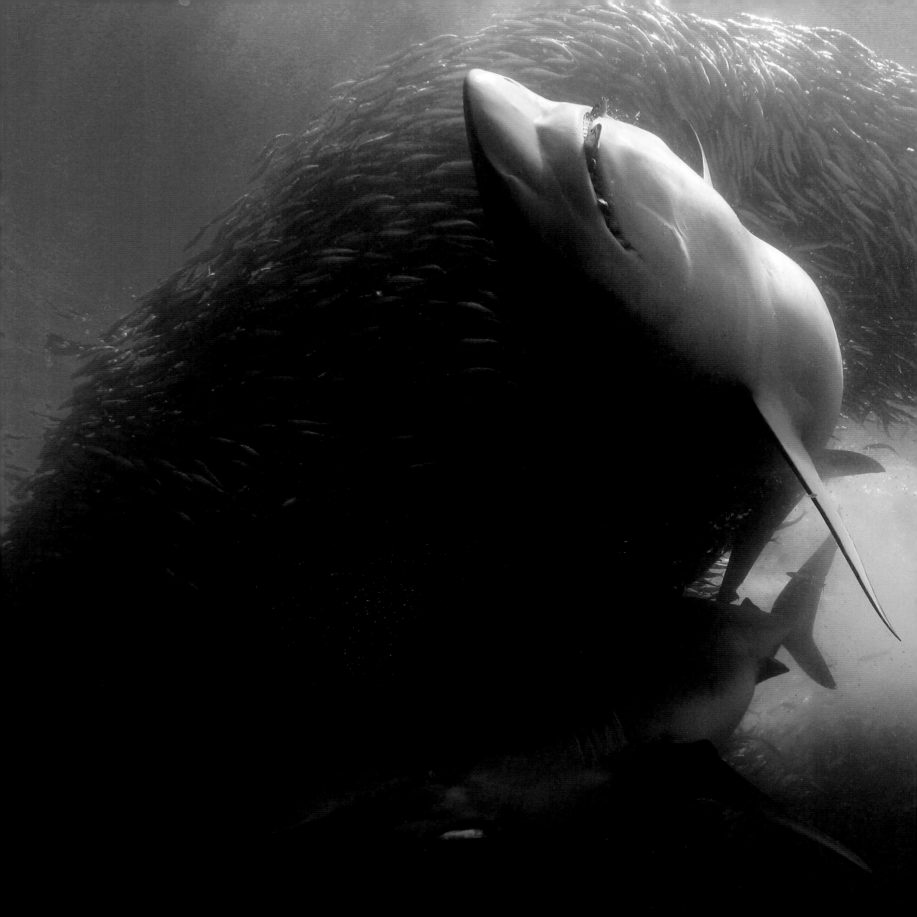

Wildlife Photographer of the Year Award
Doug Perrine

This is the photographer whose picture has been voted as being the most striking and memorable of all the competition's entries. In addition to a big cash prize, the award-winner receives the coveted title Wildlife Photographer of the Year.

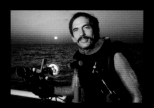

 WINNER

THE UNDERWATER WORLD

Doug Perrine
USA

BRONZE WHALERS CHARGING A BAITBALL
See page 65.

Doug Perrine is widely regarded as one the world's foremost marine wildlife photographers. He has had a varied career, as a marine biologist, a scuba-diving instructor and boat captain, an interpretative naturalist and tour leader, and a photojournalist. He is the author of seven books on marine life, and his photographs have been published in hundreds of other books and most of the world's major nature and science magazines. He has served as a consultant for filming projects for the National Geographic Society, the Discovery Channel, Disney and other companies. His photography has garnered a number of awards as well as prizes in this competition. Doug was born in Dallas, Texas, has lived in Miami, Morocco, Micronesia and Honolulu, and currently resides in Hawaii.

Innovation
Award
Pete Atkinson

This award exists to encourage innovative ways of
looking at nature. It is given for the photograph
that best illustrates originality of both composition
and execution.

**An obsession since childhood
with the ocean environment
led Pete Atkinson to study
marine zoology at Bangor
University in Wales. There he
learned to dive, taught
himself photography and
built the first of a succession
of underwater camera
housings. With the proceeds
from a house renovation, he
bought a 1935 classic yacht
and sailed off to the South
Pacific, where he has lived
and dived for the past 19
years. His current home is
Vigia, a 13.5m aluminium
yacht, which this year he has
sailed from New Zealand to
the Kermadecs, Minerva Reef
and Fiji and on to Australia.
His passion is the remote
oceanic reefs and sharks.**

GREY REEF SHARK

I sailed for 12 days from New
Zealand on this visit to
Beveridge Reef, a tiny oceanic
reef 225km south-east of Niue
in the South Pacific. It has
the rare combination of
exceptionally clear water, well
behaved sharks and great
light – usually. This day was
overcast and choppy, and so
I had few hopes for the
pictures shot that day. But
I loved the feel of quiet stealth
that the overcast and flat
monochromatic lighting gave
this shot, and the way both
the direct and refracted
images are visible.
**Subeye Reflex, with Nikon 18mm
lens and split +3 dioptre close-up
lens; 1/125 sec at f8; Fujichrome
Velvia 50; graduated
neutral-density filter.**

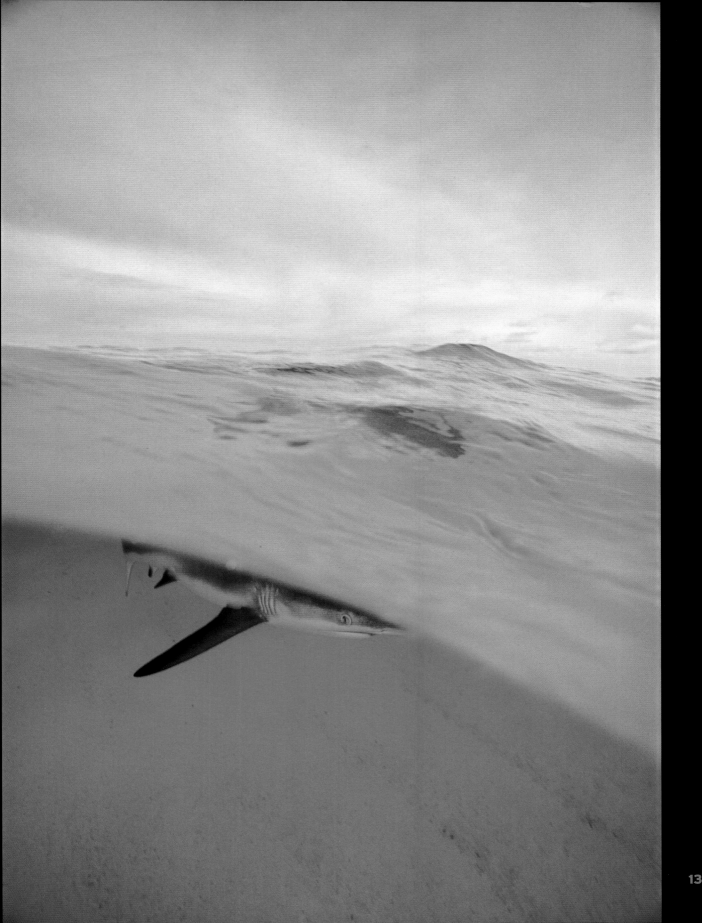

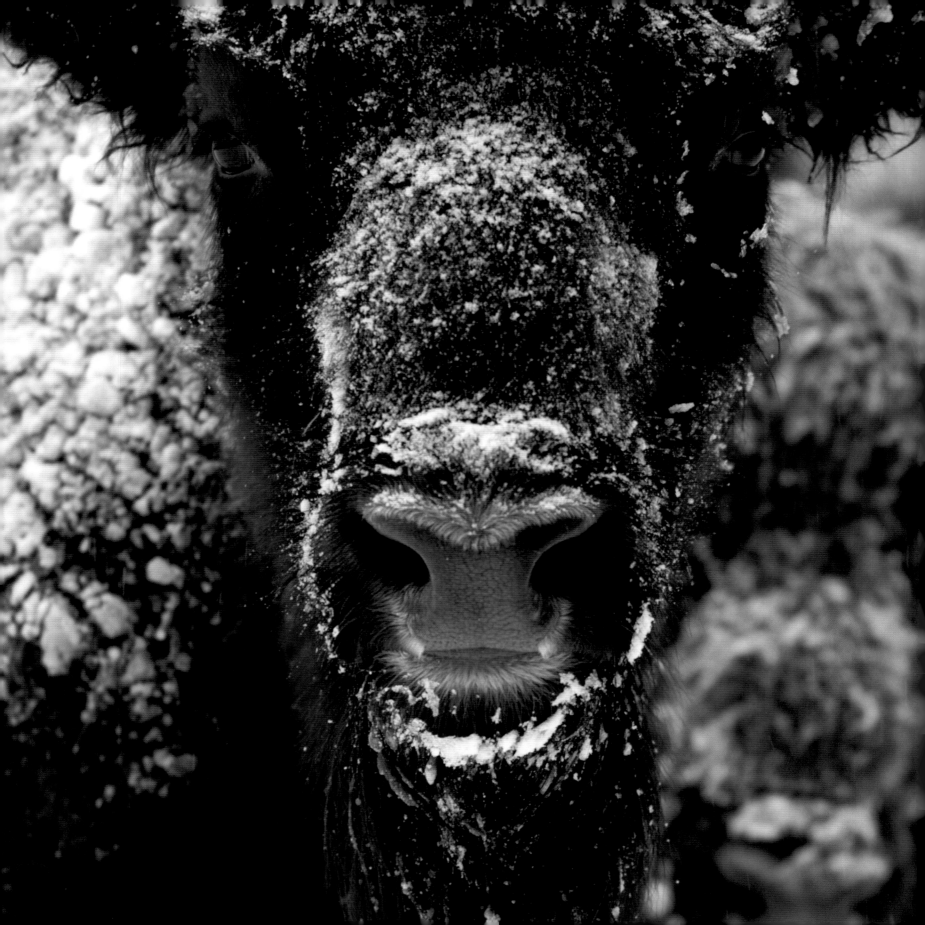

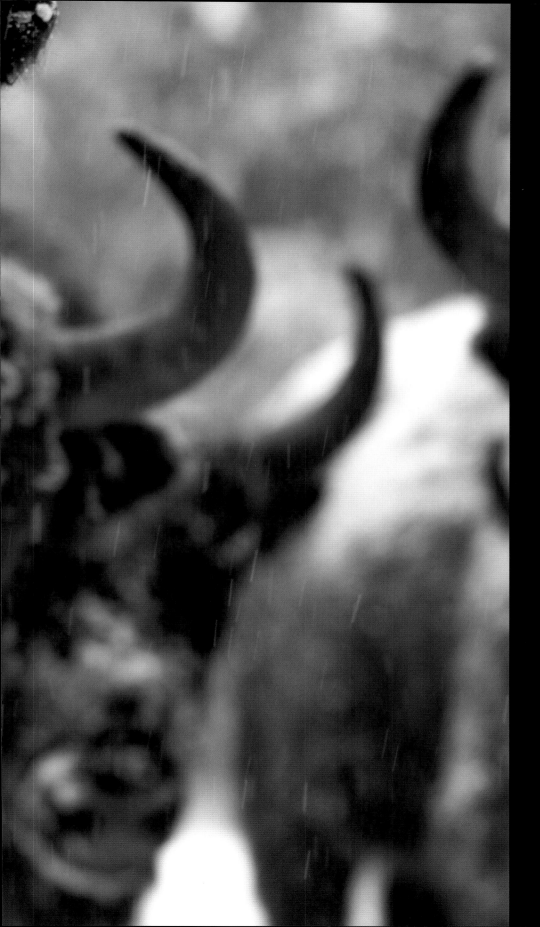

Gerald Durrell Award for endangered wildlife

This award commemorates the late Gerald Durrell's work with endangered species and his long-standing involvement with the competition. It features species that are critically endangered, endangered, vulnerable or at risk (as officially listed in the IUCN Red List of Threatened Species).

Klaus Nigge started his photographic career at 17 with a Super 8 mounted on a self-made tripod. After studying philosophy and art and taking a degree in biology, he worked as a biologist. But wildlife photography was his real passion. In 1992, he became president of the German wildlife photographer association, and in 1995, he turned full-time professional photographer and has published several books and numerous articles since then. He regards himself as a "slow photographer," returning to the same place until he really knows the environment or species. His aim is to show the animal as an individual with a personality and to achieve an intimate portrait. Rather than taking commercial, decorative pictures of animals, with strong light and bright colours, he prefers to try to achieve the subtle, everyday light that is typical of the animal's environment.

 WINNER

Klaus Nigge
Germany

CURIOUS BISON
The European bison, or wisent, once ranged through most of Europe but became extinct in the wild in 1921, when the last one was shot in Bialowieza Forest, Poland. This left fewer than 50 in captivity. After the Second World War, a breeding programme produced enough to release into Bialowieza, where I took this photo. Since 1980, 24 herds have been established in Poland, Russia, Belorussia and Ukraine. In Bialowieza, the animals are truly wild and difficult to get close to. I set up my hide in a clearing where they come to feed. This group arrived in the early morning after a night of heavy snow. Though they couldn't see me, they were obviously aware of something unusual and stared intently towards the camera.
Nikon D100 with 80-200mm lens; 1/90 sec at f4; digital 200 ISO.

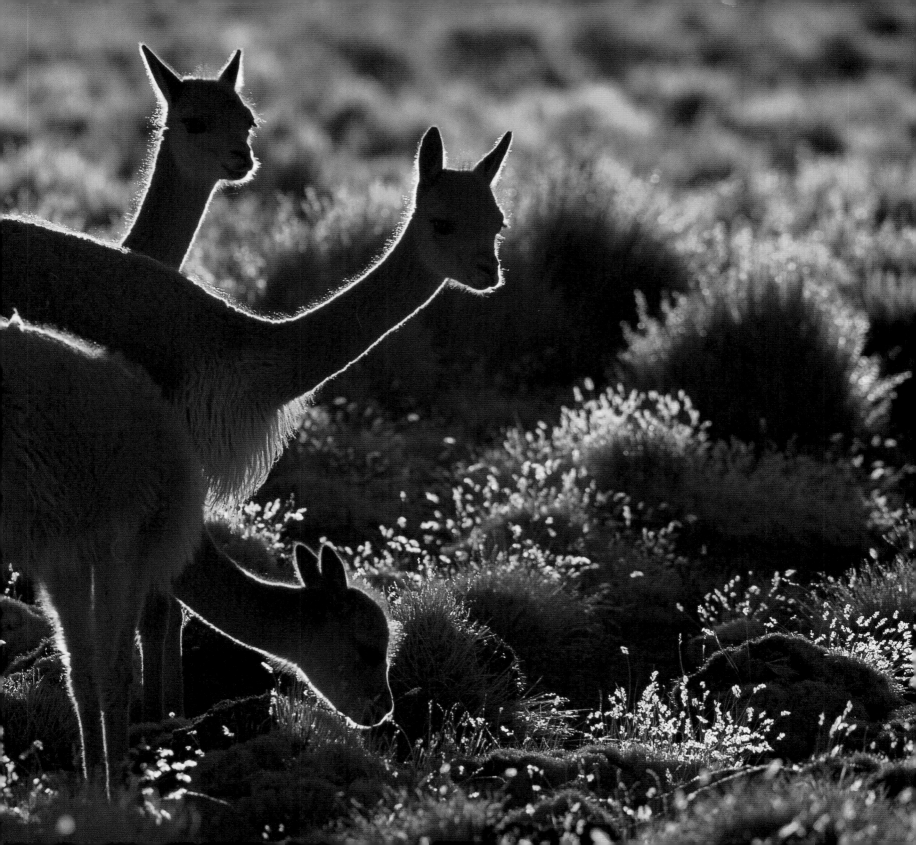

Anup Shah

UK

STROLLING CHIMPANZEE
This leisurely strolling
chimpanzee was bringing up
the rear of a group travelling
in the morning along a
well-worn path to a feeding
area in the chimps' home
range in Mahale Mountains
National Park, on the shores
of Lake Tanganyika in
Tanzania. Though Mahale's
chimp population is relatively
large and secure, it numbers
fewer than 1,000 individuals.
Elsewhere in western and
Central Africa, rapid
deforestation and the
commercial trade in ape and
monkey bushmeat mean that
chimpanzees are now
seriously endangered.
Canon EOS 1V with 135mm lens;
Fujichrome Provia 100.

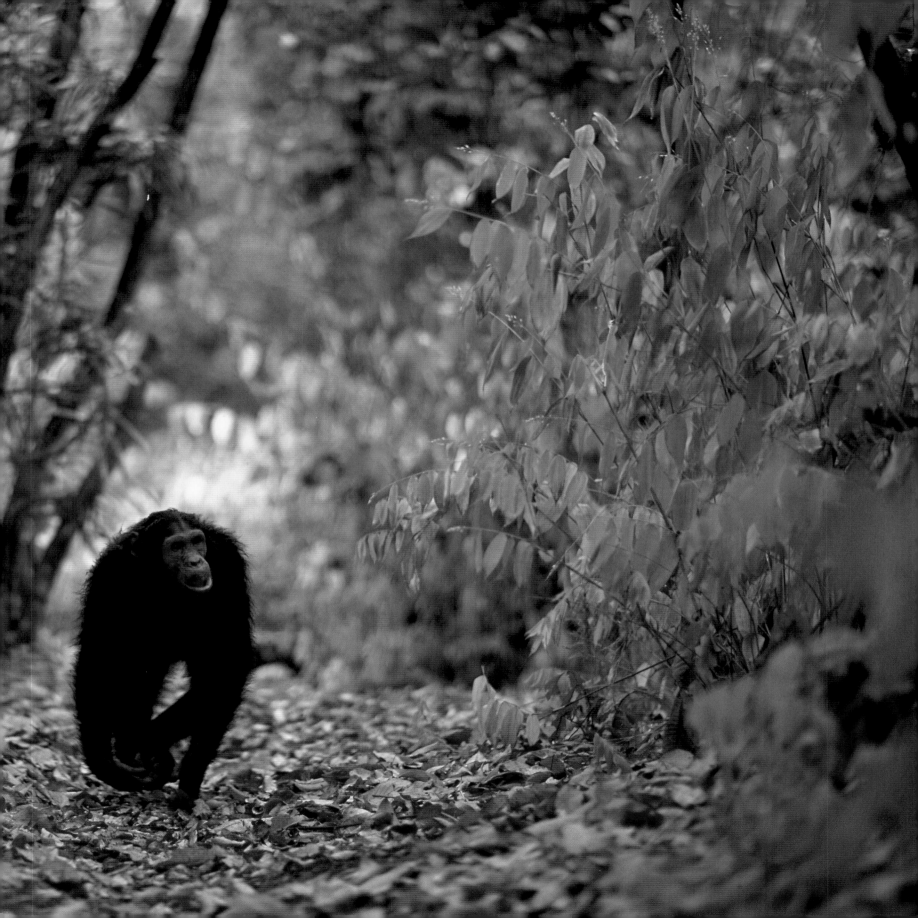

A L Harrington
UK

ETHIOPIAN WOLVES

The Ethiopian wolf is the rarest canid on Earth – fewer than 500 remain. When in January 2004, I visited the Bale Mountains in Ethiopia, the wolves were suffering a rabies outbreak. These two are the remnants of the Kotera pack, which had lost nine out of fourteen animals. They were sitting with trepidation at the edge of their territory and suddenly took off over the hill into a neighbouring pack's area, possibly sensing that other wolf groups, too, were under-numbered and that they would not be challenged. It is depressing to see a critically endangered species suffer such a massive loss. But the Ethiopian Wolf Conservation Program is vaccinating the wolves and the dogs of the local people, and, with luck, this should help the recovery of the wolf population.

Nikon F5 with 500mm lens; 1/125 sec at f5.6; Fujichrome Provia 100; bean bag.

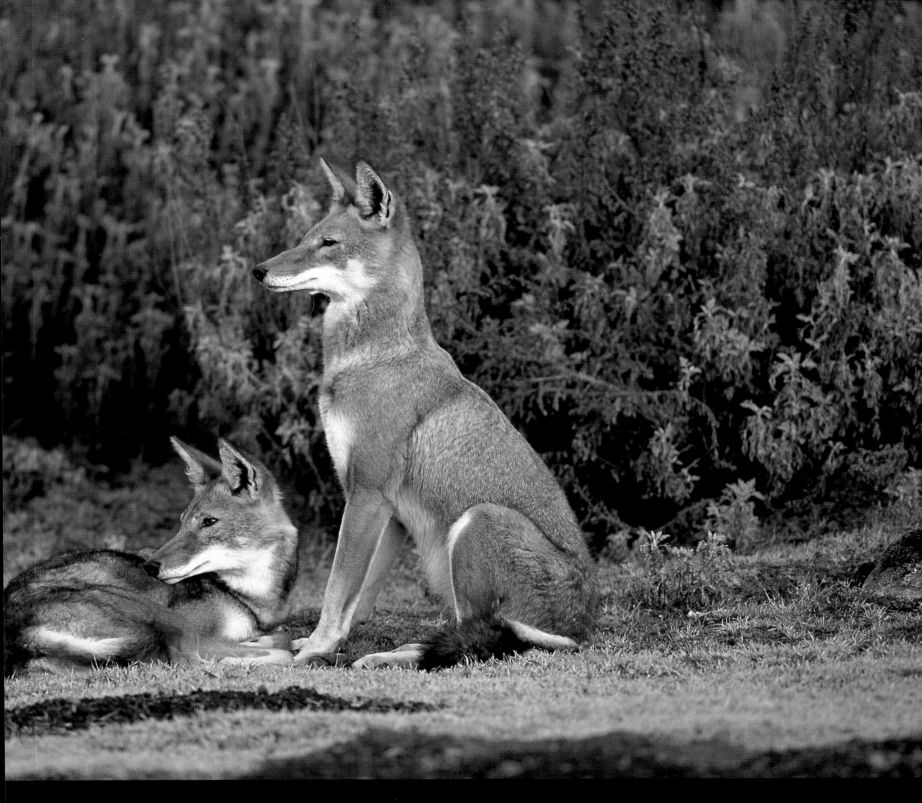

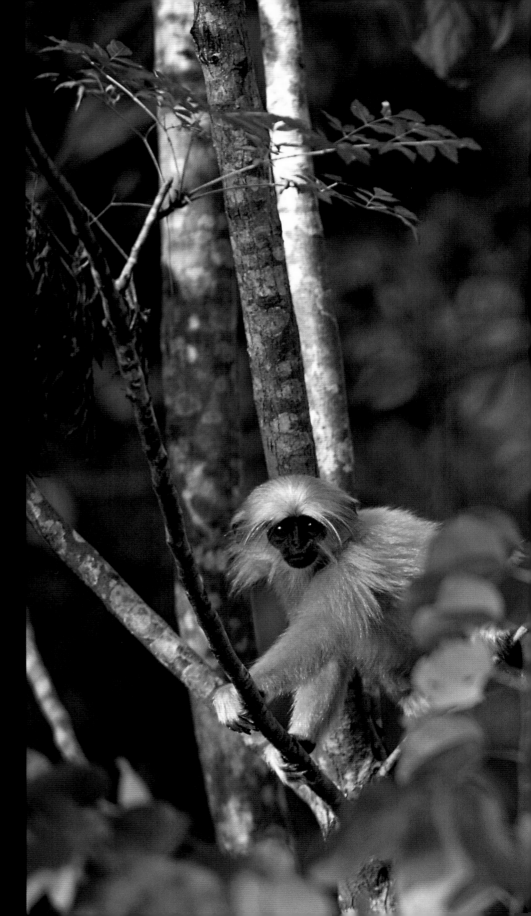

HIGHLY COMMENDED
Elio Della Ferrera
Italy

GOLDEN LEAF MONKEYS
This dominant male has just usurped the resting place of an adolescent, who is now moving off to join the rest of the 12-strong troop feeding in the dense forest canopy. Only 2,000 golden leaf monkeys (golden langurs) remain in the wild, surviving in increasingly fragmented patches of forest. Some live in this hilly area and in other forest patches in north-west Assam (north-east India), the rest in Bhutan. Listed as endangered, the species continues to decline, mainly because illegal logging is destroying its habitat. While photographing the monkeys, I sometimes heard the distant thud of axes, even though the area is protected. And at night, I saw people cycling along the edge of the forest carrying blocks of freshly cut wood.
Canon EOS 1 N with 300mm lens and 1.4x extender; 1/125 sec at f4; Fujichrome Provia 100F; tripod.

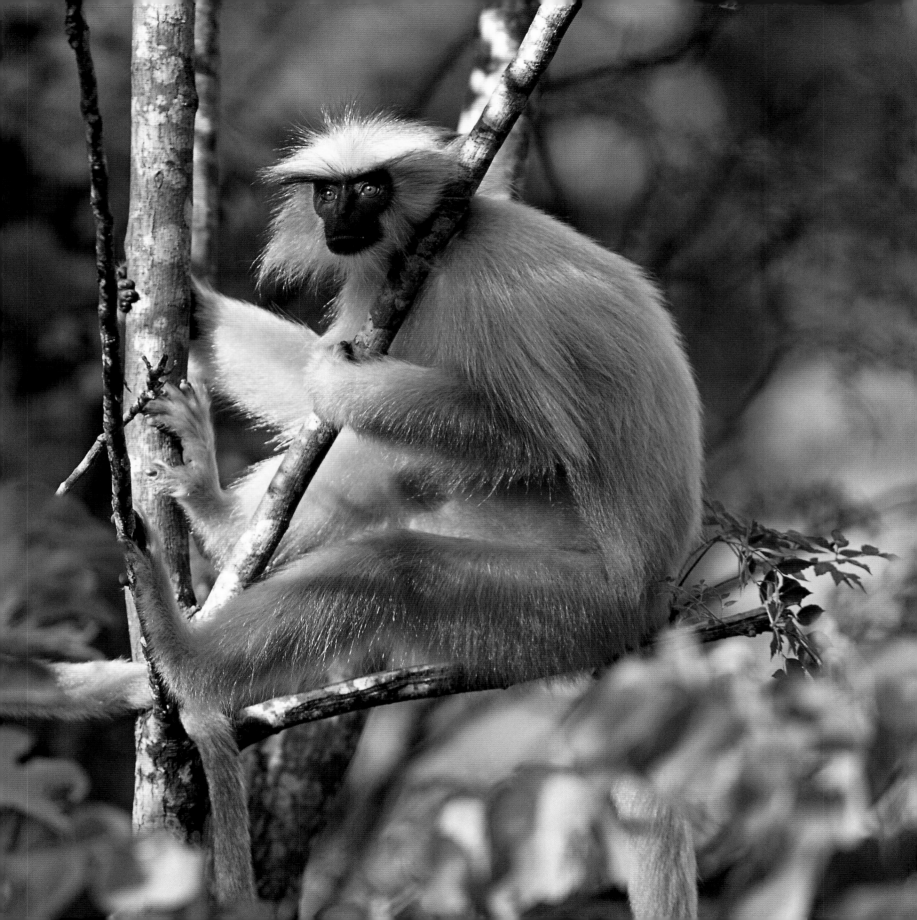

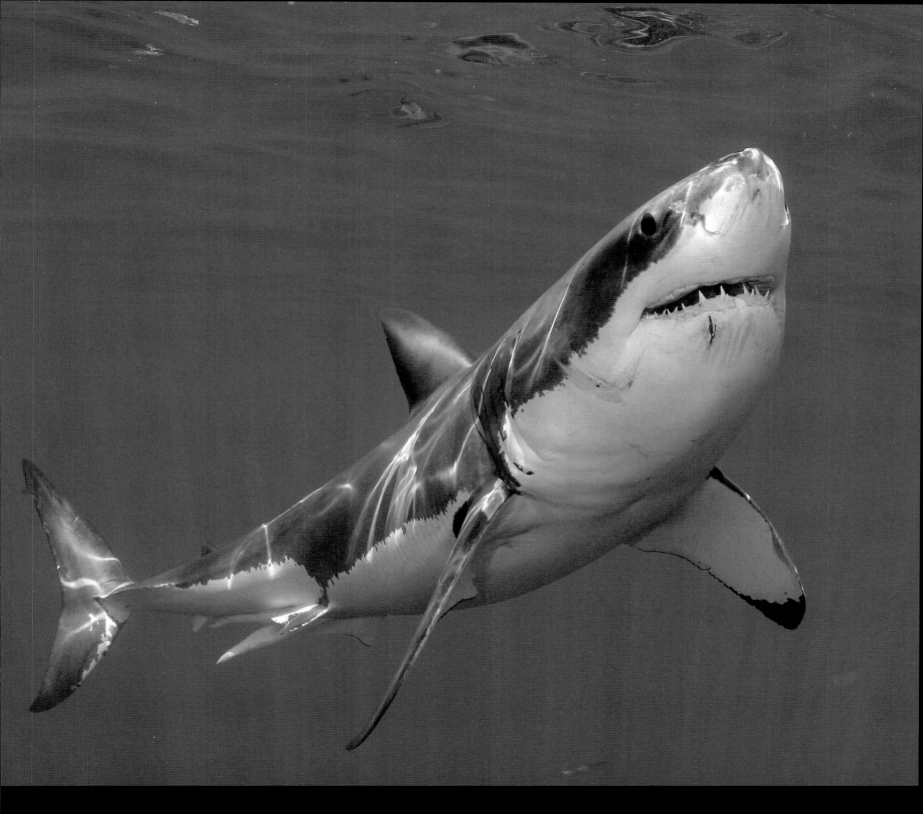

Animals in their environment

In these photographs, the habitat must be as important a part of the picture as are the plants or animals being shown. The image must also convey a sense of the relationship between the plants or animals and the habitat they are in.

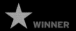 **WINNER**

Howie Garber
USA

YACARE CAIMAN IN SUNLIGHT

I visited the Pantanal (Brazil) in May at a time when many of the pools and lakes that are scattered over this extensive wetland area were starting to dry up and the wildlife was beginning to concentrate around the remaining water. This caiman was in a pool beside an elevated road, from where I took the shot. Caiman make ideal photographic models: they lie perfectly still in the sun and tolerate people's presence at close range.
The time of day, angle of the sun and use of a warming polariser combined to give the scene its golden glow.
Pentax 645 with 120mm lens; 1/8 sec at f22; Fujichrome RDP III 100; warming polariser; tripod.

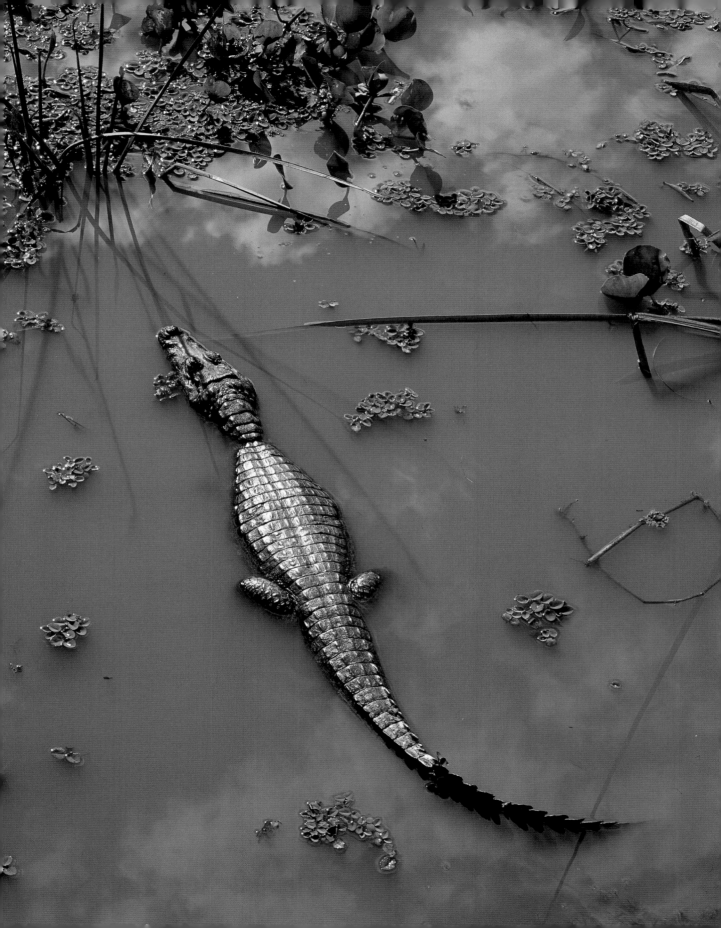

 RUNNER-UP

Michel Roggo
Switzerland

LURKING PIKE

While photographing in the Doubs River in eastern France, I reached a calm part with almost no current. I hung just beneath the surface, composing images from the lines of elegant water plants. A pike approached me through the weed, as though checking out trespassers. It slowly glided into my picture, pausing for a moment in the shadow of the leaves, its pectoral fins flickering, before retreating with a couple of swift movements of its tail, presumably to a place where it could wait in ambush for passing fish.

Canon T70 with 24-1.4mm lens; automatic setting; Fujichrome Sensia 100; Hugyfot housing.

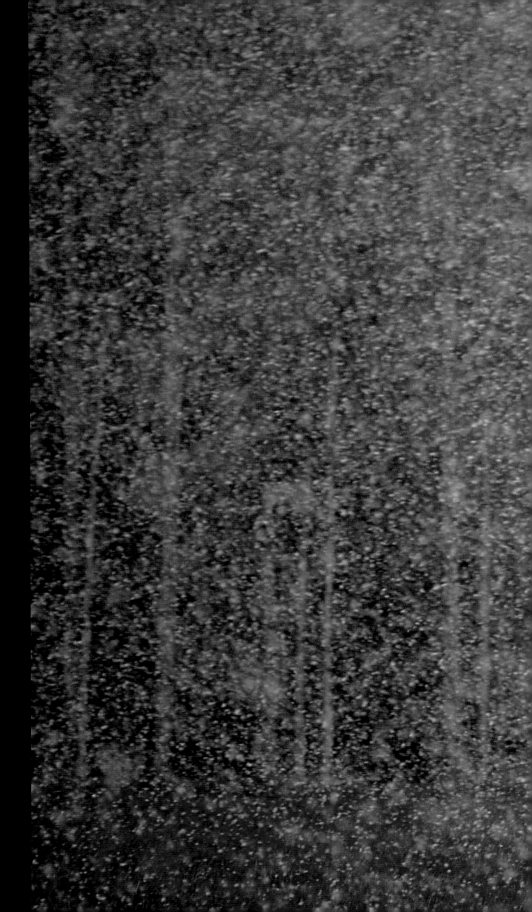

...GHLY COMMENDED

...kka Niskanen
...nland

**...HOOPER SWANS
...A SNOWSTORM**

...hough it was already May,
...ate frost caused the
...mperature in Sukeva,
...uth-west Finland, to fall to
...ro. After four hours
...hotographing ruffs from a
...de near a pond, I was
...eezing and decided to go
...ome. As I packed up, snow
...egan to fall. I quickly thought
...bout how I might make good
...hotographic use of this turn
...events and remembered
...e pair of whooper swans
...had seen in a field a couple
...kilometres away. To my
...elight, they were still there.
...hortly after I arrived,
...ough, the snow stopped,
...e swans took flight and the
...oment was gone forever.

**...anon EOS 3 with Canon
...5-400mm 5.6 IS lens;
...30 sec at f5.6; Kodak
...ktachrome E100VS.**

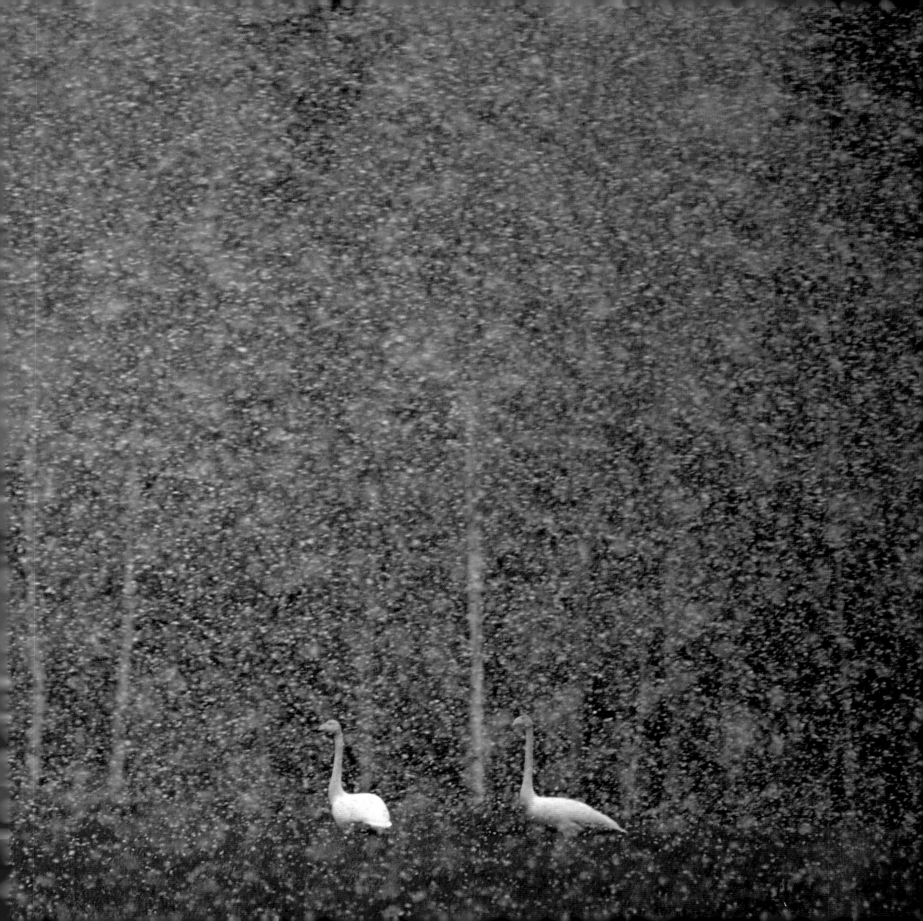

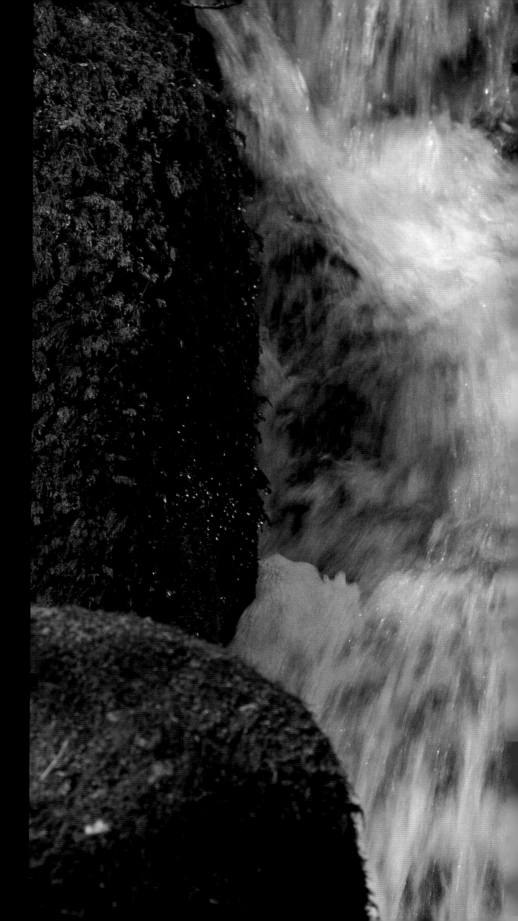

HIGHLY COMMENDED

Daniel Magnin
France

DIPPER

For the past two years, I have watched a pair of dippers with a territory around the Vauze waterfall in the south of Burgundy. They build their nest of moss on the rocks nearby. To hunt, they dip their heads below the surface, sometimes even walking along the river bottom, in search of aquatic larvae to eat or to take back to their chicks. They occasionally rest on these rocks just in front of the waterfall, where I set up my hide. It had rained heavily the day before I took this picture, and so the river was swollen, and the spume from the waterfall created a mist over the dark, moss-covered rocks.

Canon EOS 3 with 100-400mm 4.5-5.6 lens; 1/15 sec at f16; Kodak Elite Chrome 100; tripod.

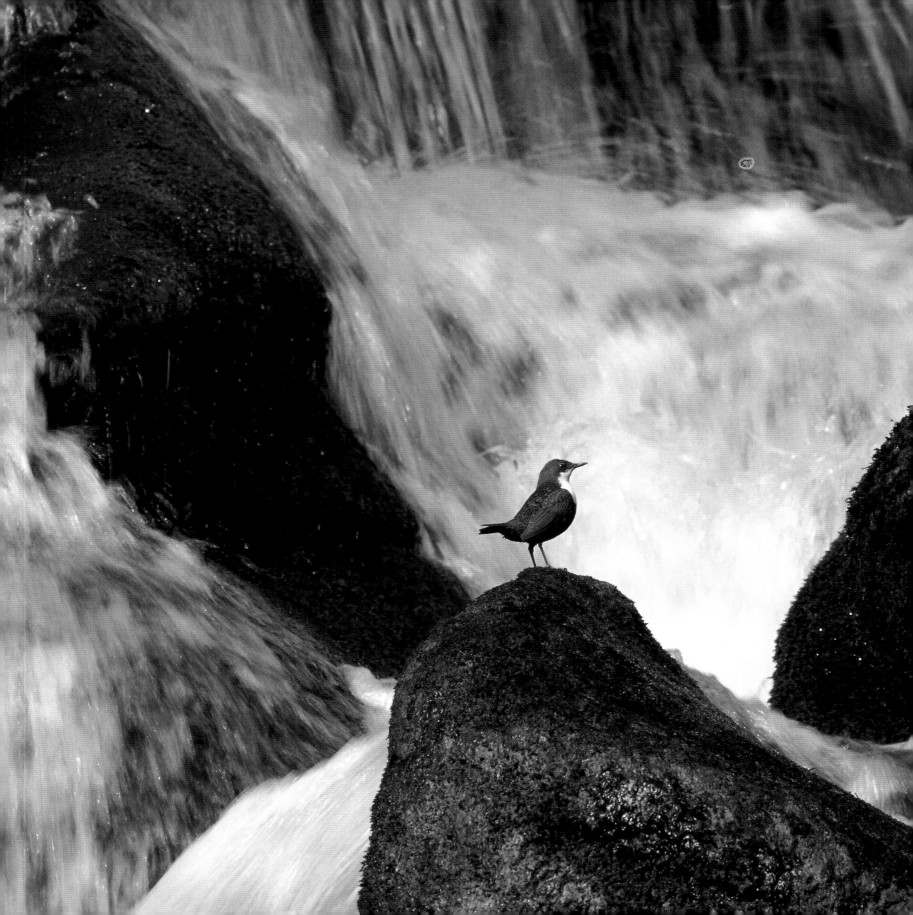

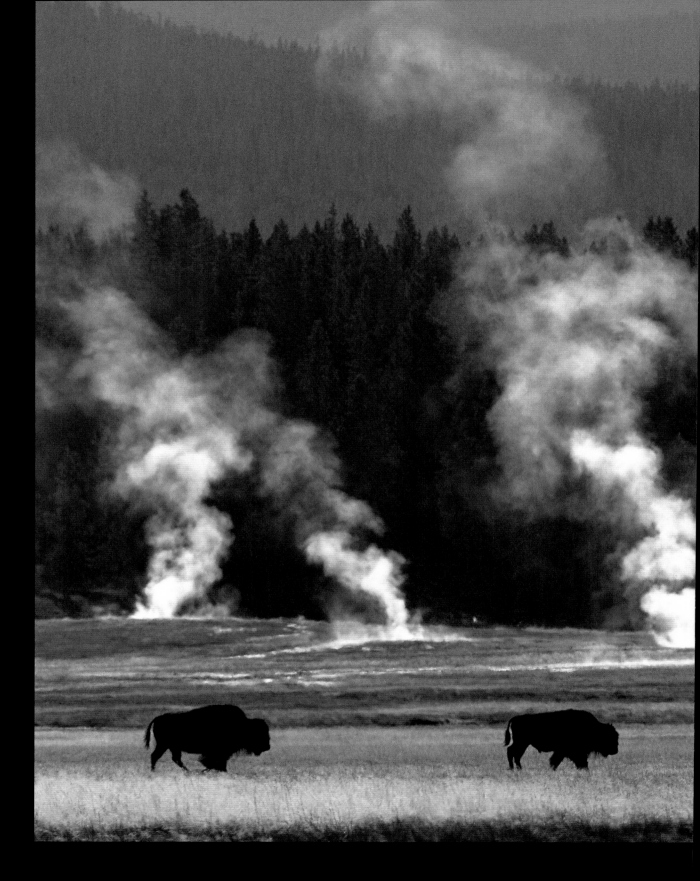

Peter Cairns
UK

BISON PROCESSION

The 3,600 bison in Yellowstone National Park comprise the major remnant of the vast herds of up to 90 million that once roamed across the great plains of North America. In winter, they gain warmth from the hot steam that rises from natural geysers, the result of underground geothermal activity. On this freezing autumn morning, a large herd of bison filtered out of the forest and began to cross the plain in front of the steaming vents. Though I could immediately see the potential of the setting, there were too many animals to make a picture work. These four bison were almost the last to appear, in perfect symmetry.

Nikon F5 with 500mm lens;
Fujichrome Velvia 50.

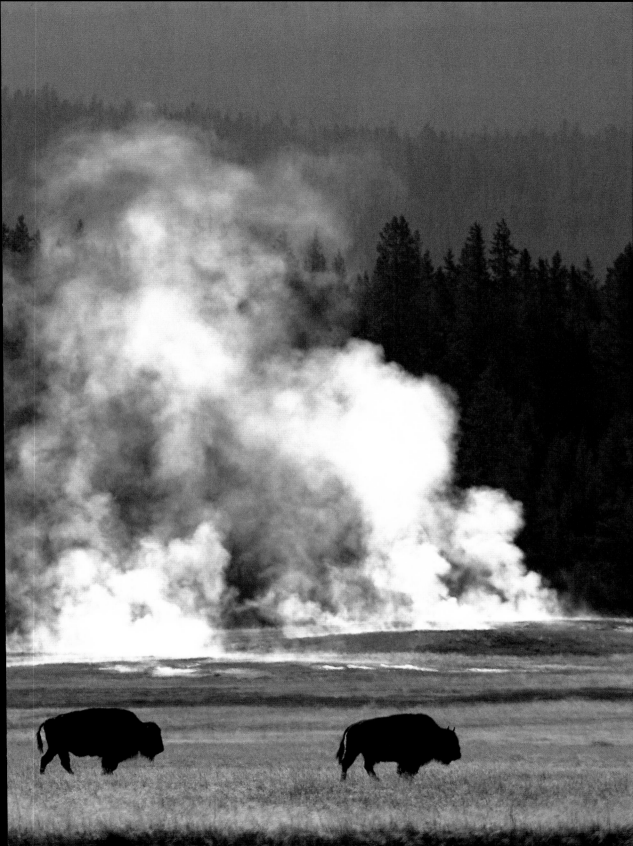

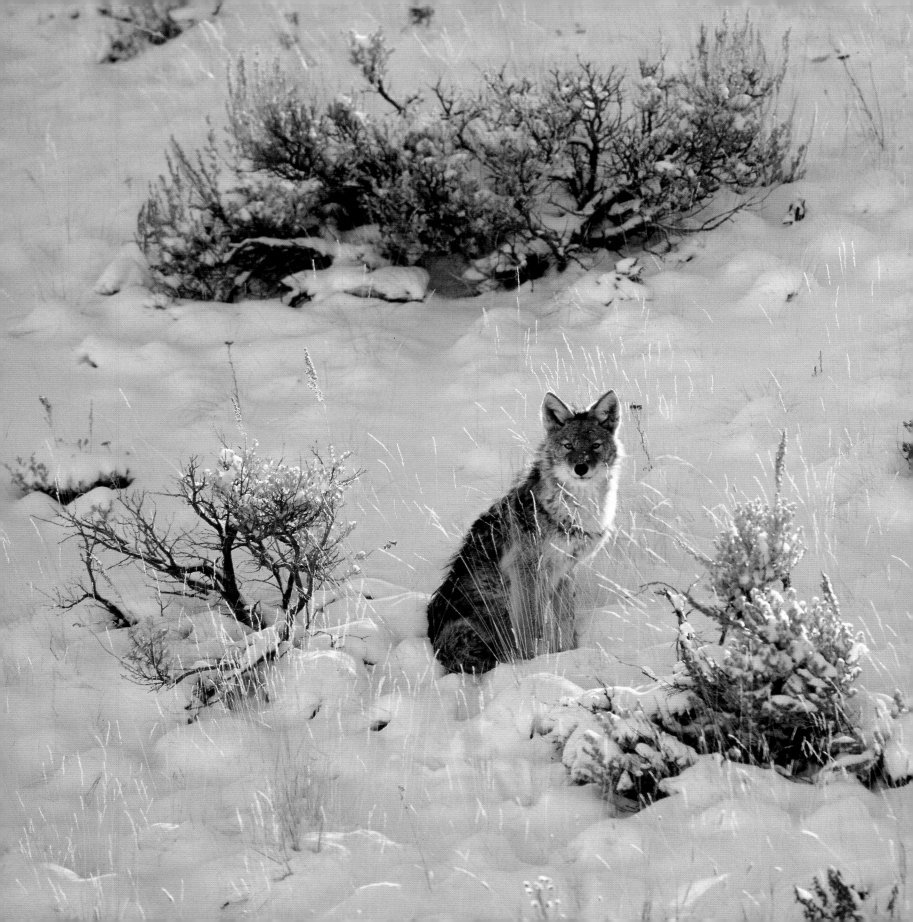

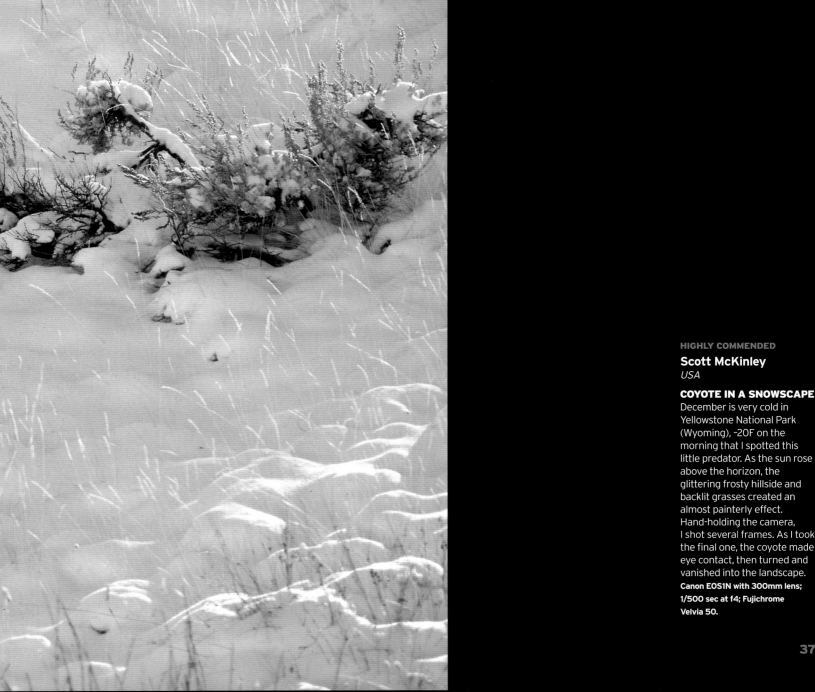

HIGHLY COMMENDED

Scott McKinley
USA

COYOTE IN A SNOWSCAPE

December is very cold in Yellowstone National Park (Wyoming), -20F on the morning that I spotted this little predator. As the sun rose above the horizon, the glittering frosty hillside and backlit grasses created an almost painterly effect. Hand-holding the camera, I shot several frames. As I took the final one, the coyote made eye contact, then turned and vanished into the landscape.

Canon EOS1N with 300mm lens; 1/500 sec at f4; Fujichrome Velvia 50.

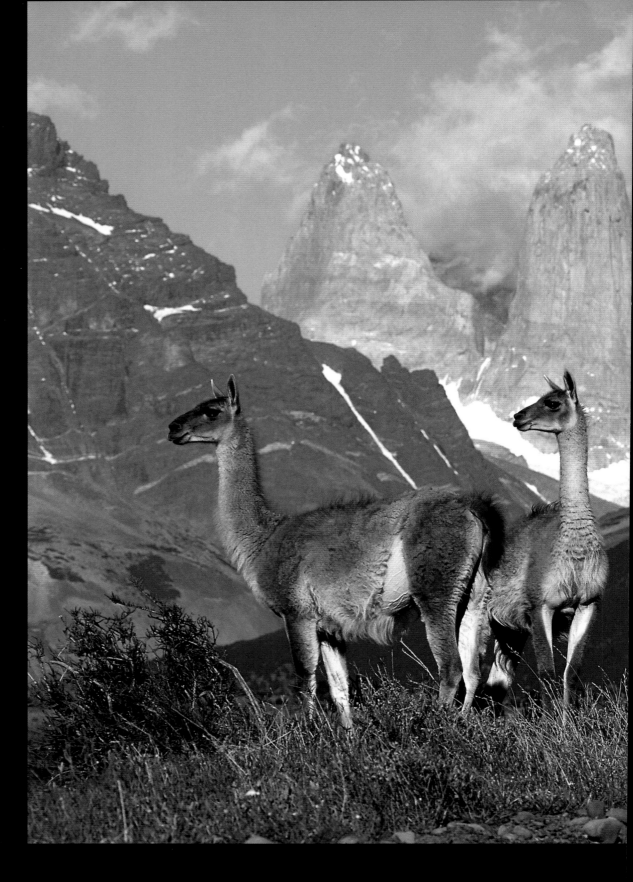

Cornelia & Ramon Dörr
Germany

GUANACOS

Driving early one morning on the way to Amarga Lagoon in Chile's Torres del Paine National Park, we were lucky to encounter this family group of guanacos grazing in the most perfect of photographic positions, in front of the famous peaks and with a backdrop of blue sky and cloud. Ramon quickly set up the tripod, and I managed to take two frames with the animals looking at our car before they resumed grazing. The guanaco – closely related to the domesticated llama – once numbered in the millions but is now threatened throughout its South American range.
Nikon F100 with 80-200mm f2.8 lens; 1/125 sec at f8; Fujichrome Velvia 50; tripod.

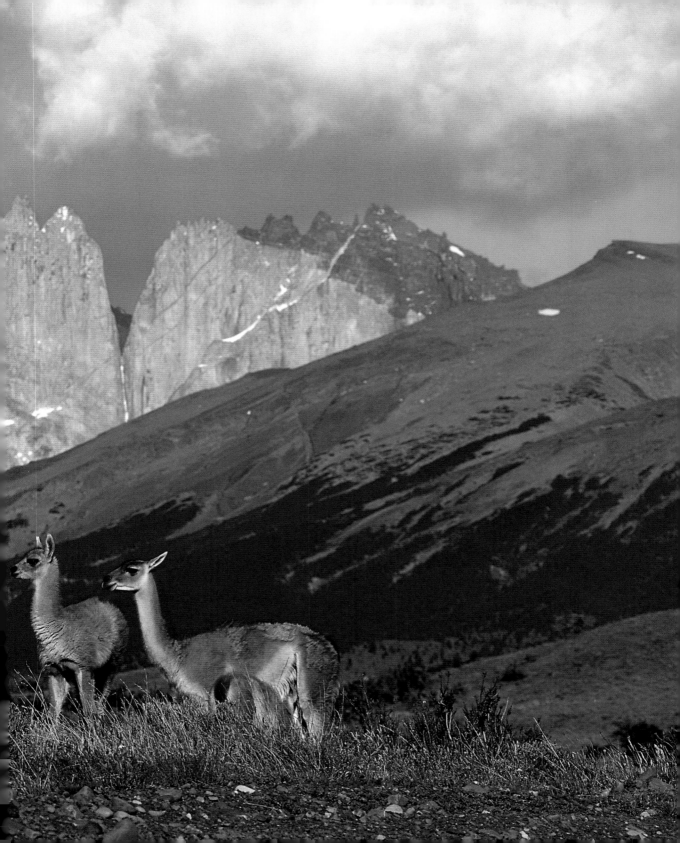

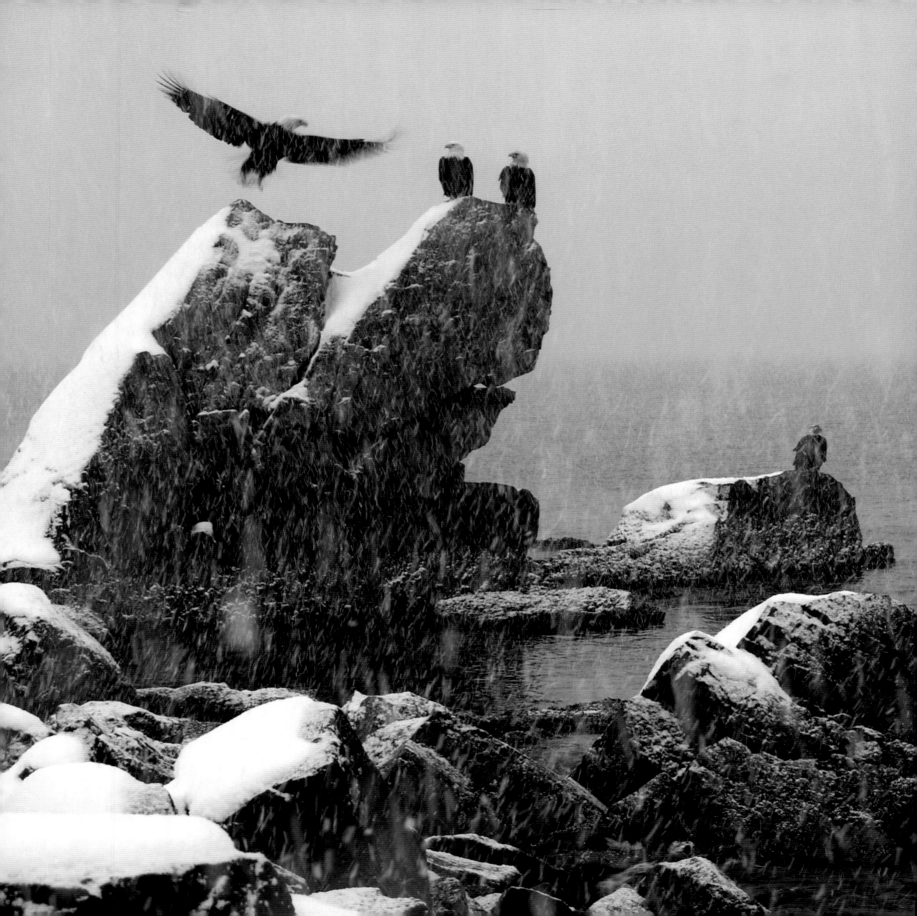

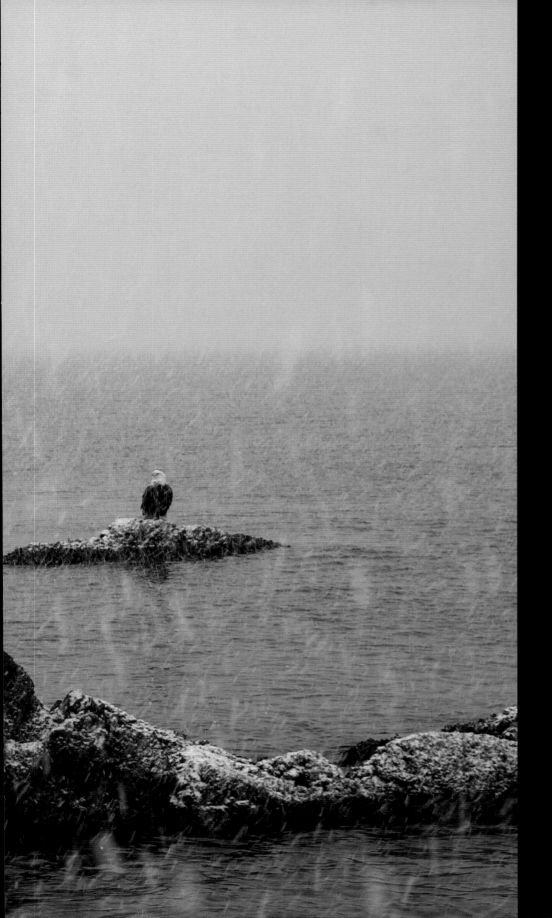

HIGHLY COMMENDED

Klaus Nigge
Germany

BALD EAGLES
IN MID-WINTER

I travelled to Alaska's Aleutian Islands in winter especially to photograph the bald eagles, which gather here in large numbers to feed on the abundant fish. On this particularly cold and bleak day, I spent nearly eight hours photographing them with my telephoto lens, packing up only when it started to get dark. But just after I had put my lens away, it began to snow. There was something magical about the silence and the change of light. Then I saw these eagles gathering on rocks out in the sea – the perfect picture. When I got back to camp and looked at the digital image I had taken, it summed up for me perfectly what eagle life on the Aleutians in winter is really like.

Nikon D1 with 28-105mm f3.5-4.5 lens; 1/30 sec at f5; digital 160 ISO.

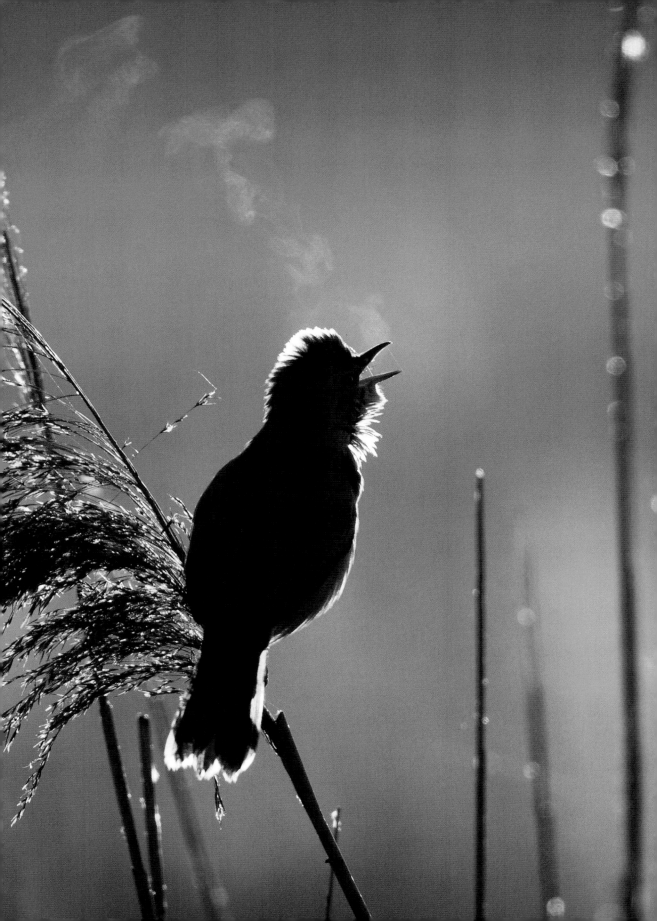

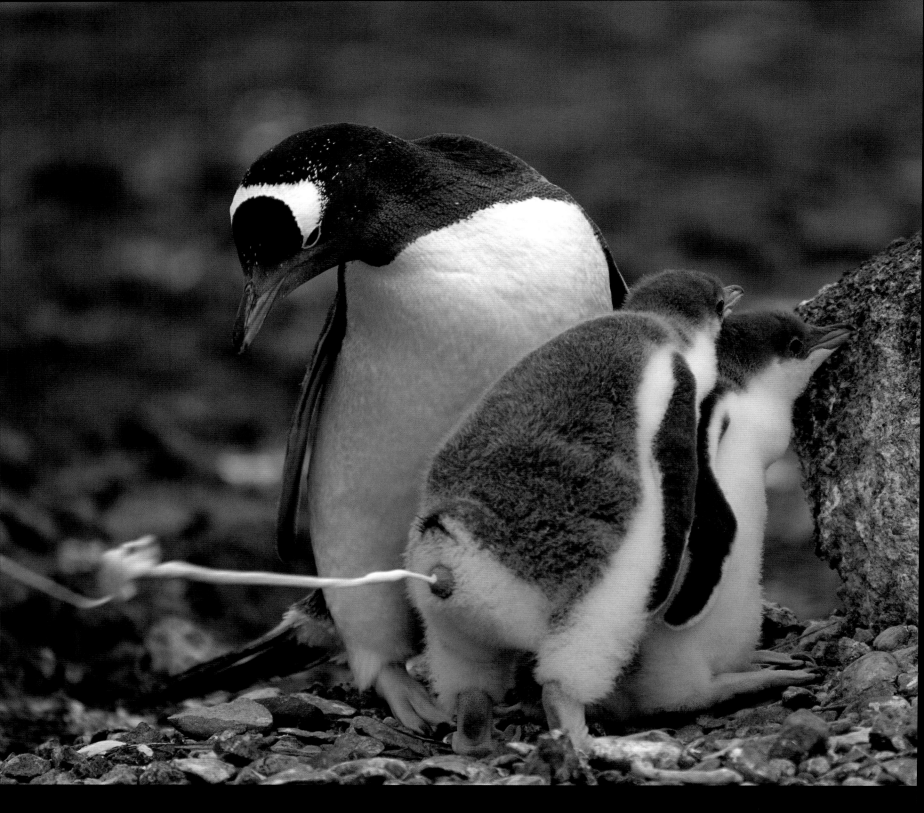

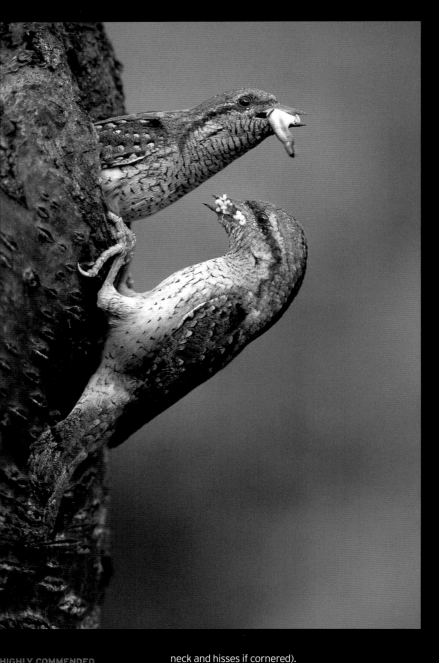

Bence Máté
Hungary

WHITE-TAILED EAGLE AND CROWS

I have spent hundreds of hours trying to photograph white-tailed eagles, mostly in vain, as they are persecuted and therefore shy. Last year, I discovered a protected area where carcasses are put out for these endangered eagles. I built several hides and used the first one on New Year's Day. Presuming the eagles would be wary, I used a long lens. At 10am, all the smaller birds suddenly disappeared, and a curious calm set in. A minute later, an eagle landed right in front of me, so close I couldn't fit it into my view-finder. Here, crows pluck up courage to try to steal titbits under the beak of the feeding giant.

Canon EOS1-N RS, with FD 800mm SSC lens and EOS-FD converter; 1/80 sec at f7.1; Fujichrome Velvia 50.

HIGHLY COMMENDED
Josef Stefan
Austria

WRYNECK PARENTS

Wrynecks are usually quite shy, feeding mainly on the ground, on ants. When disturbed, a wryneck will freeze and transform itself into an old branch or stump of wood (the name apparently comes from the snake-like way it twists its neck and hisses if cornered). The best time to observe these sparrow-sized woodpeckers is in the breeding season. I was lucky that this pair decided to nest in my garden. Here, the male is taking out one of the chick's faecal pellets just as his mate arrives back with a beakful of ant eggs for the family.

Nikon F4 with 500mm f4 lens; 1/125 sec at f5.6; Fujichrome Sensia 100; camouflage tent.

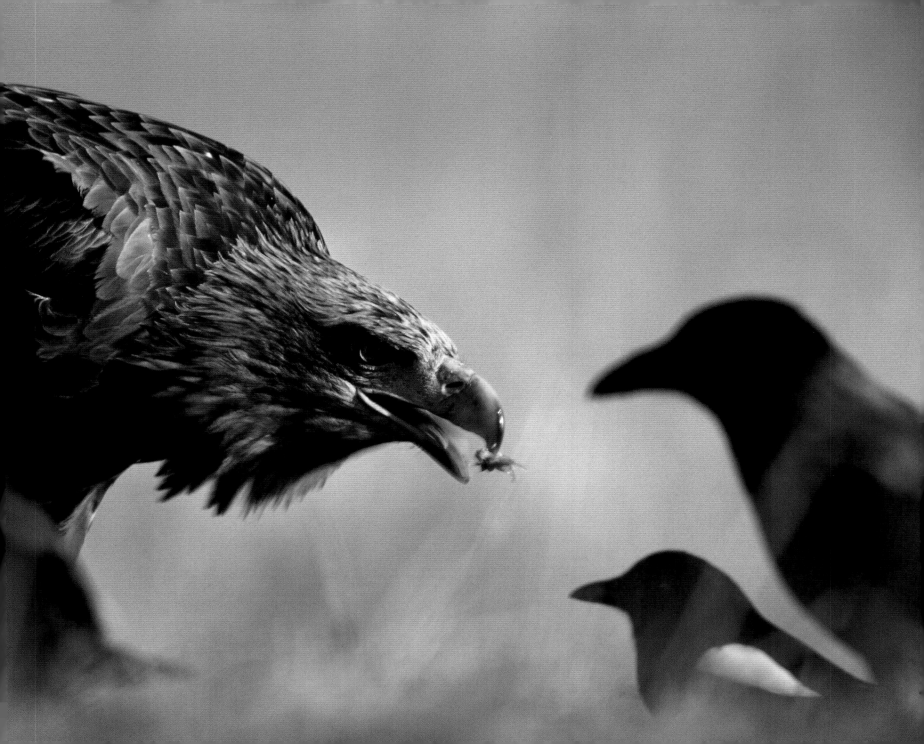

Animal behaviour
Mammals

These photographs are selected for their interest value as well as their aesthetic appeal, showing familiar as well as seldom-seen active behaviour.

 WINNER

Anup Shah
UK

GOLDEN JACKAL CHASING A LESSER FLAMINGO

Lake Makat, inside Tanzania's Ngorongoro Crater, attracts many predators, particularly hyenas and golden jackals. They are after the lesser flamingos, which come in their thousands to feed on the vast blooms of spirulina algae in the shallow, warm soda lake. This jackal spent a while targeting a bird and then accelerated through the shallows in hot pursuit, causing the nervous flock to take off in a flurry of wings and legs.

Canon EOS 1V with 600mm lens; Fujichrome Provia 100.

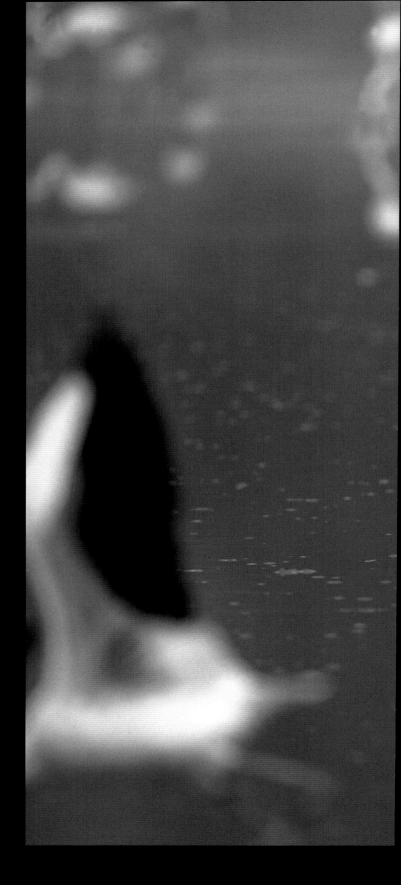

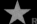 **RUNNER-UP**

Johann C Mader
South Africa

BABY ELEPHANT PLAYING

In the dry months, herds of African elephants come to drink at the permanent waterways in Botswana's Moremi Game Reserve. This herd had a calf with them that was just a few weeks old. The elephants approached the shallows together and quenched their thirst. Then the youngster splashed down into the water, playing and rolling under his mother's four protective legs. After quite a time, the mother decided that playtime was over and nudged her baby to his feet.

Nikon F5 with AF-S Nikkor 600mm f4 lens; 1/250 sec at f4; Fujichrome Provia 100F rated at 100.

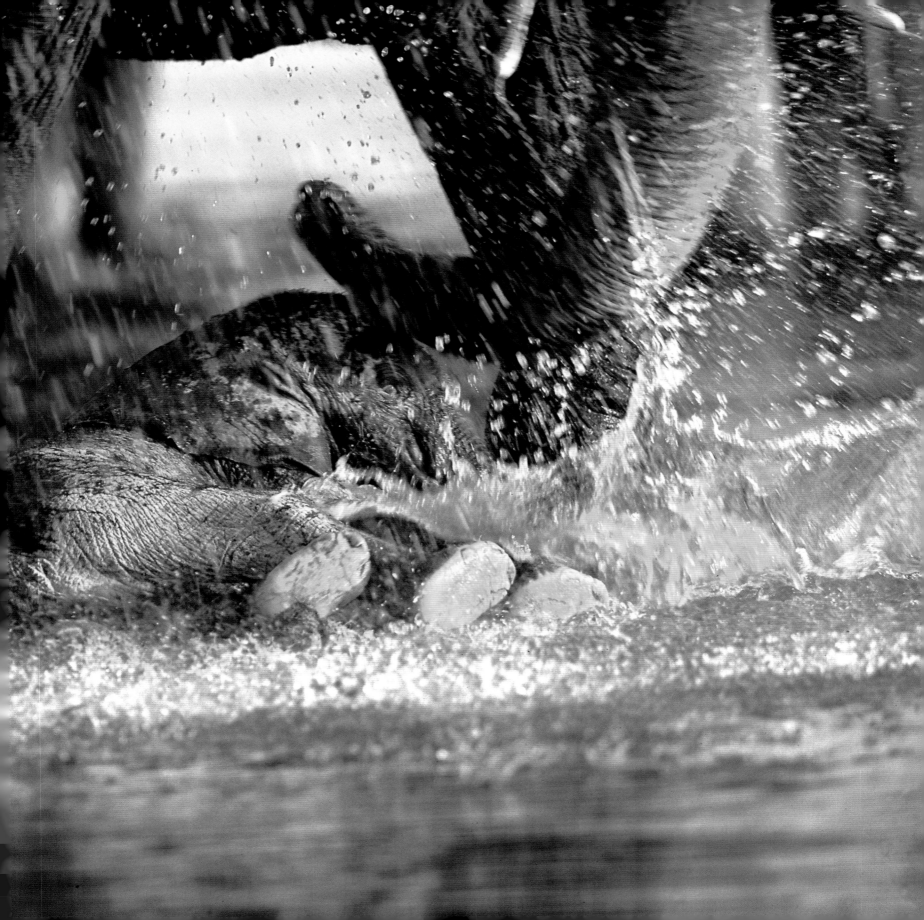

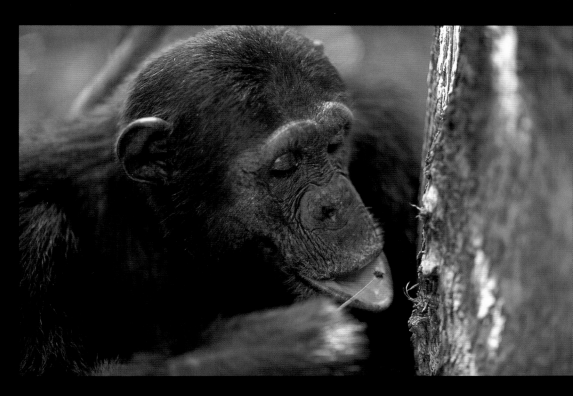

Anup Shah
UK

CHIMPANZEE FISHING FOR TREE ANTS

This is one of a couple of male chimps in Tanzania's Mahale Mountains National Park taking turns to fish for ants, the more dominant of the companions going first. Using twigs they'd modified for the job by tearing off the leaves, they would dip a twig into a hole in the trunk, wait a few seconds for the defending ants to grab it and then bring it out and lick off the titbits. This technique is routinely taught to the youngsters in the group. Other tools that chimpanzee groups are known to use include stone hammers and anvils for cracking open nuts, twigs as toothpicks and leaves as sponges and tissues.

Canon EOS 1V with 135mm lens;
Fujichrome Provia 100.

HIGHLY COMMENDED
Steven J Kazlowski
USA

ARCTIC FOX POUNCING ON PREY

I spent one spring living on the central Arctic coast of Alaska. On a cloudy afternoon in May, I watched an Arctic fox hunting some distance away. It seemed to be listening intently to something scrabbling under the snow. Suddenly, the fox leapt up into the air, a metre or so above the ground, and pounced, front paws first. It did this again and again – stop, listen, pounce. It gradually got closer to me and eventually came within range of my lens. All that hard work failed to bear fruit, though – the fox never did catch its dinner.

Nikon N90-S with 500mm lens;
1/250 sec at f4;
Fujichrome Sensia 100.

Gerald Hinde
South Africa

CHEETAHS PLAYING
I have been documenting
the lives of these two subadult
cubs and their mother in
Phinda Game Reserve in
KwaZulu-Natal, South Africa,
for quite a time. Late one
afternoon, while their mother
was trying to hunt, the
adolescents started to
play-fight. The light was low,
and I panned the shot with
a slow shutter speed to
create the blurred effect.
Once their mother leaves
them, the youngsters will stay
together for at least six more
months, and being males,
they may even remain
hunting partners for life.
**Canon EOS 1V with 70-200mm
lens; automatic setting; Fujichrome
Velvia 50.**

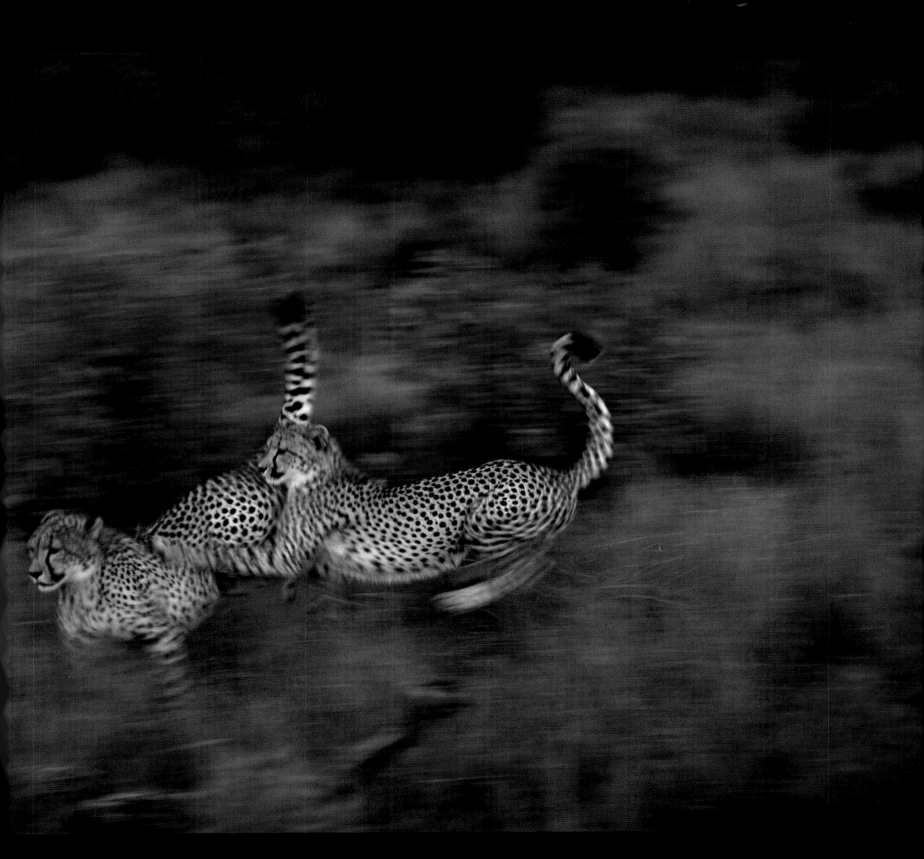

Behaviour
All other animals

This category offers plenty of scope for interesting pictures, given that animals other than mammals and birds comprise the majority of animals on Earth and have behaviour that is often little known.

 WINNER

Christian Ziegler
Germany

CAT-EYED SNAKE EATING RED-EYED TREEFROG SPAWN
In the lowland rainforests of Central America, red-eyed treefrogs glue clutches of eggs to leaves overhanging forest ponds so that the developing tadpoles are safe from predators such as fish or dragonfly larvae. But there are other predators, such as this cat-eyed snake, that specialise in eating frog eggs. To counter them, the red-eyed treefrog has evolved a neat exit strategy. Normally, the tadpoles don't hatch until they are six days old. But, from the age of four days, the premature tadpoles hatch spontaneously if attacked, wriggling their way across the leaf and dropping to the water below.
Canon EOS 1V with 100mm f2.8 macro lens; 1/100 sec; Fujichrome Velvia 50; flashes.

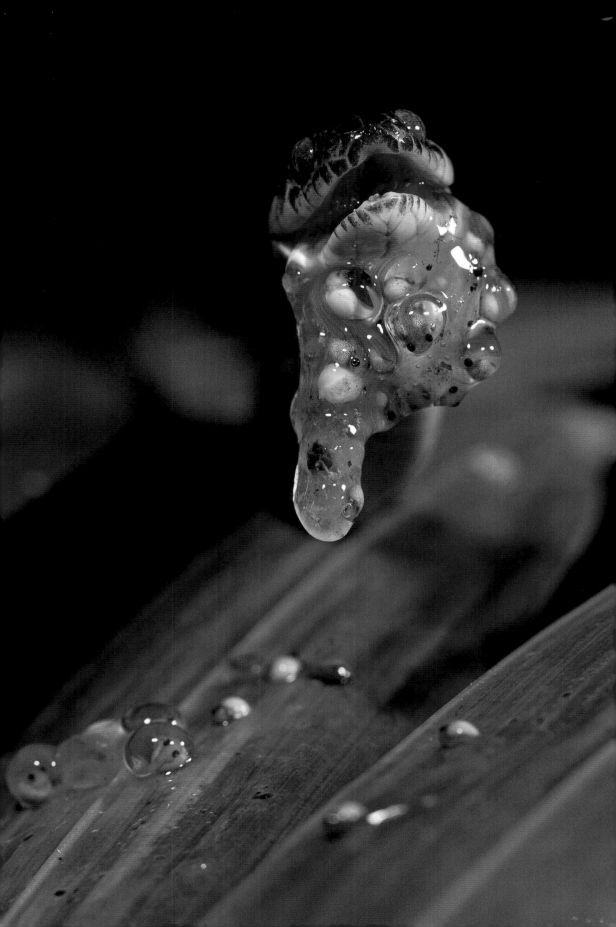

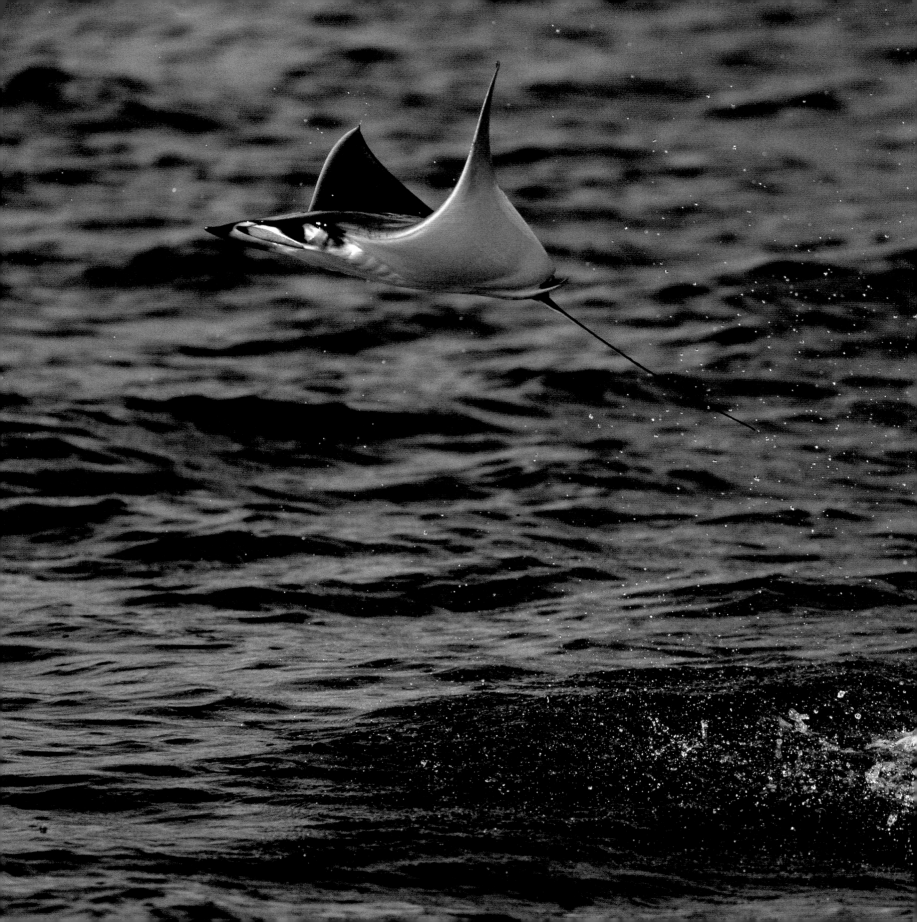

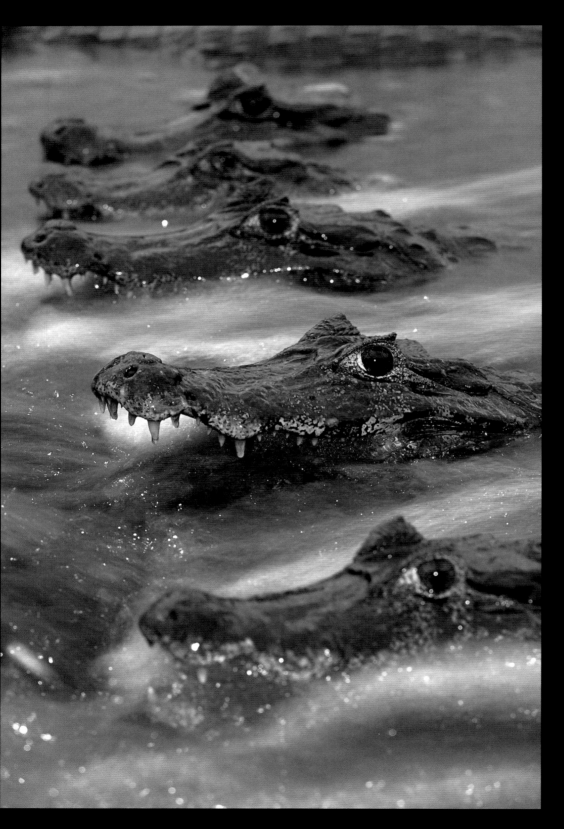

Mark Jones
New Zealand

YACARE CAIMAN IN AMBUSH

After a day's sunbathing on the riverbank, the caiman's slow-lane lifestyle shifts up a gear, and at dusk, the gang heads off to feed in the river. The reptiles, which can grow up to three metres long, line up, stock-still with jaws agape. The water flushes across their teeth, and fish are snapped up with loud 'clops'. Standing in the fast-flowing water at the outfall of a marshy lake in the Pantanal, the world's largest wetland, I slowly approached this row of caimans. The beauty of slow-time exposure is that, while the camera does its thing, you have hands free to swat the industrial-strength mosquitoes.

Nikon F5 with 300mm lens; Fujichrome Provia 100; tripod with ball head; strobe with fresnel lens.

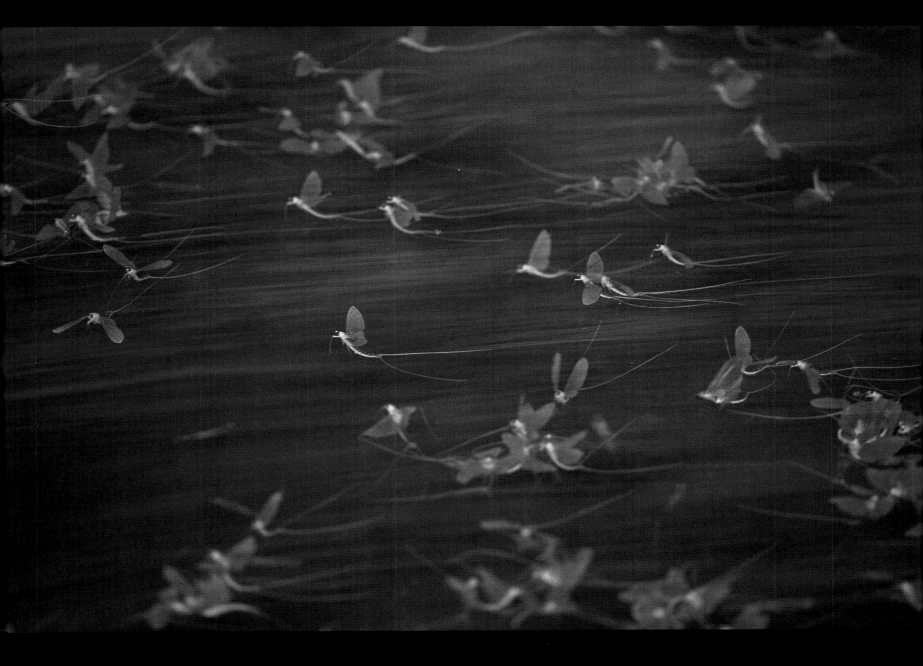

József L Szentpéteri
Hungary

MAYFLY SWARM
As larvae, mayflies live for three years on the bottom of riverbeds; as adults, they survive just a couple of hours. Once a year, millions rise to the surface and hatch into beautiful winged adults.

They swarm above the water, desperately trying to mate and lay their eggs before dying. In Hungary, the biggest swarms of long-tailed mayflies (the largest species in Europe – males are up to 120mm long) occur on the River Tisza.

A small 'pre-swarm' alerted me a week or so before that the phenomenon was imminent. This actual swarm was so thick that I could hardly see the opposite bank.
Canon EOS 1V with Canon 400mm f4 DO IS lens; 1/2-1/6 sec at f4-f6.3; Fujichrome Velvia 50; synchronised flash.

61

Tobias Bernhard
New Zealand

CLOWN NUDIBRANCH LAYING EGGS

While diving in the Poor Knights Islands Marine Reserve in New Zealand, I examined a clump of sea-lettuce swaying vigorously in the swell of the sea (it makes such a colourful, clean background for a picture) and was surprised to find this large clown nudibranch attaching its egg rosette to a frond. Why the nudibranch had chosen such a flimsy substrate was a mystery, and you can imagine what focusing on a nudibranch moving back and forth half a metre was like.

Nikon F4 with Nikon 105mm macro lens; 1/60 sec at f4.5; Fujichrome Velvia 50; Subal housing and two Nikon SB 26 flashguns in home-made housing.

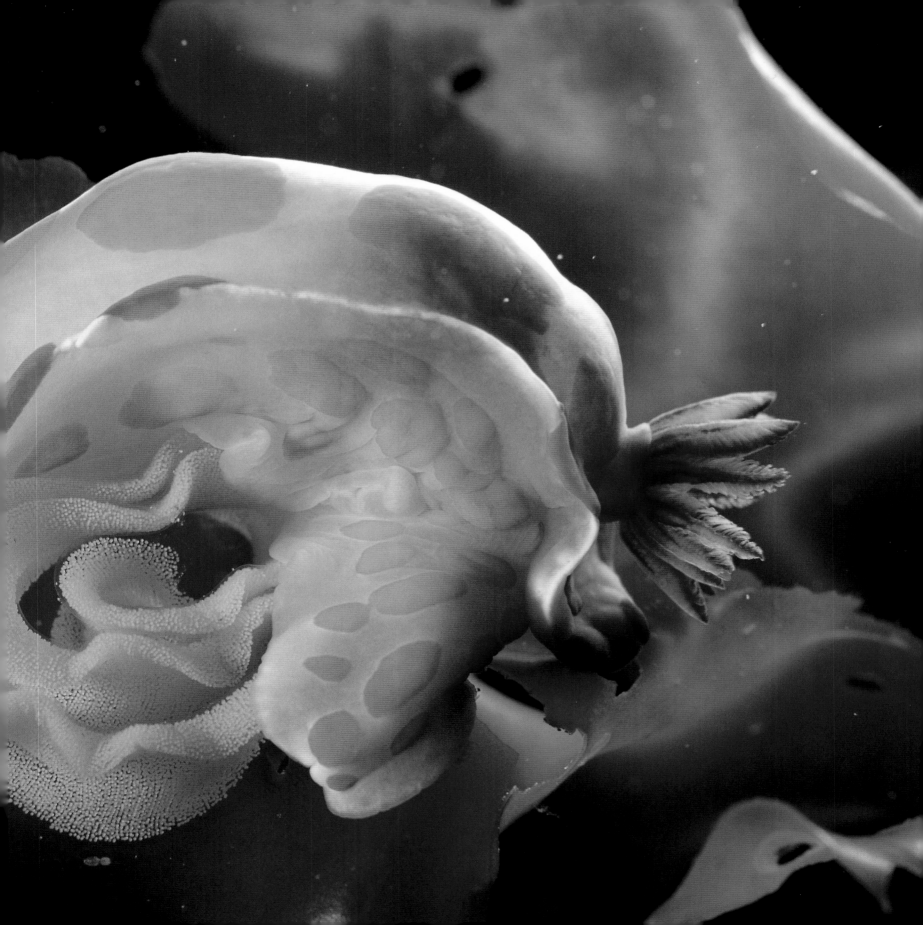

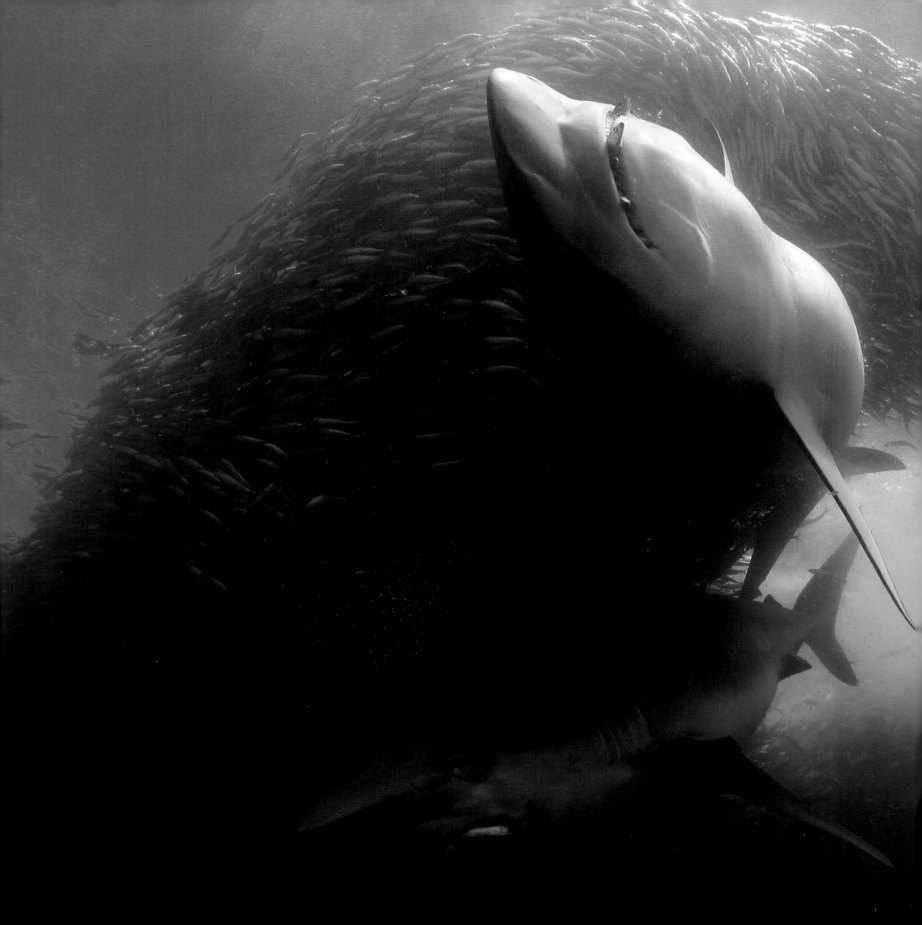

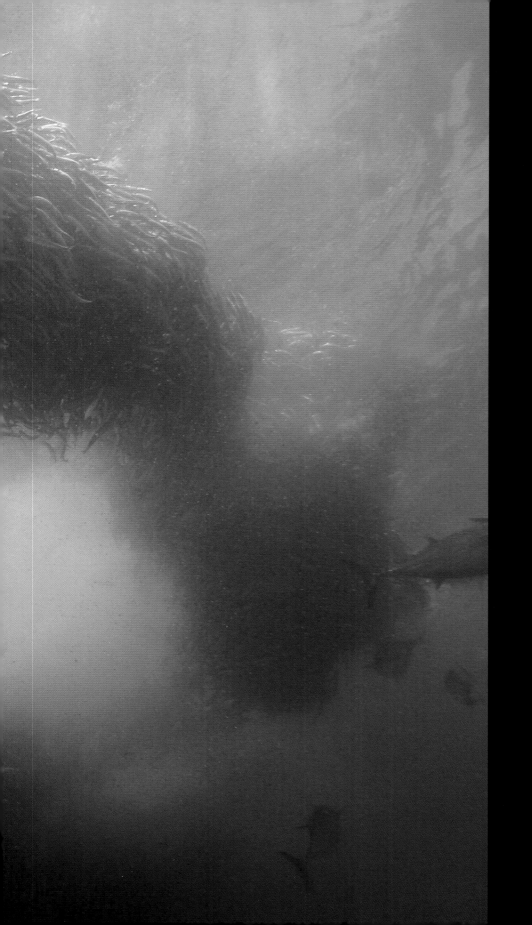

Unde
world

These photographs c
freshwater animals or
important criteria are
interest value is also t

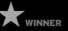

WINNER

Doug Perrine
USA

BRONZE WHALERS
CHARGING A BAITBAL

During the annual sardine
run, vast shoals of sardine
migrate up the east coast
South Africa. A kilometre
Transkei's Wild Coast, a po
of common dolphins herd
sardines to the surface in
'baitball'. Other predators
soon rushed in, including
bottlenose dolphins, tuna,
Cape gannets and thousa
of sharks. The sharks wou
charge through the baitba
bursting through the othe
side or shooting clear out
the water, their mouths
stuffed full of fish. So
intent were they on feedir
that they often bumped
me as they rushed past.
It was one of the most int
experiences of my life.
Canon EOS D60 with Sigma 14
f2.8 lens; 1/800 sec at f5.6; di
ISO 200; Canon 550EX strobe
UK-Germany underwater housi

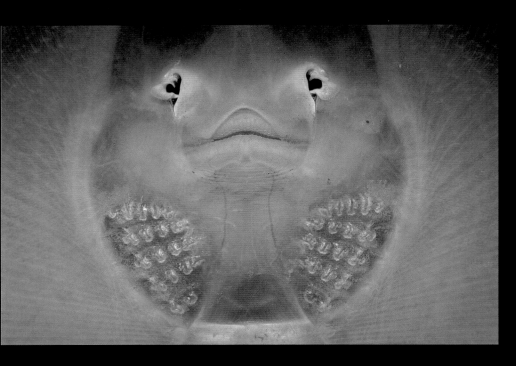

HIGHLY COMMENDED

Angel M Fitor
Spain

SPOTTED RAY 'FACE'

This picture was taken off south-eastern Spain at a depth of 36 metres. The spotted ray is common in deeper areas here but quite rare in shallower water. I came across a dozen of them while looking for razorfish to photograph. Resurfacing to change my camera lens, I prayed that the rays would still be there when I dived back. I struck lucky. After swimming for ages below several of them – and wasting nearly all my film looking for this ventral view – I had to do several decompression stops on the way back to the surface. But I got the shot I wanted of the mouth (the eyes of the fish are, of course, at the side of its head).

Nikon F90X with 60mm lens; 1/125 sec at f11; Fujichrome Velvia 50; Aquatic housing; strobe.

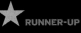 **RUNNER-UP**

Doug Perrine
USA

BRONZE WHALER AT THE SARDINE FEAST

This shark was one of hundreds feeding on the baitball, dashing in to snatch mouthfuls of fish. The shoal of sardines was by now a remnant of its former size, and within half an hour, the sharks had eaten the last fish, leaving nothing but an oily sheen on the water's surface.

Canon EOS D60 with Sigma 15mm f2.8 lens; at 1/200 sec at f5.6; digital ISO 200; twin Inon Z220 underwater strobes; UK-Germany underwater housing.

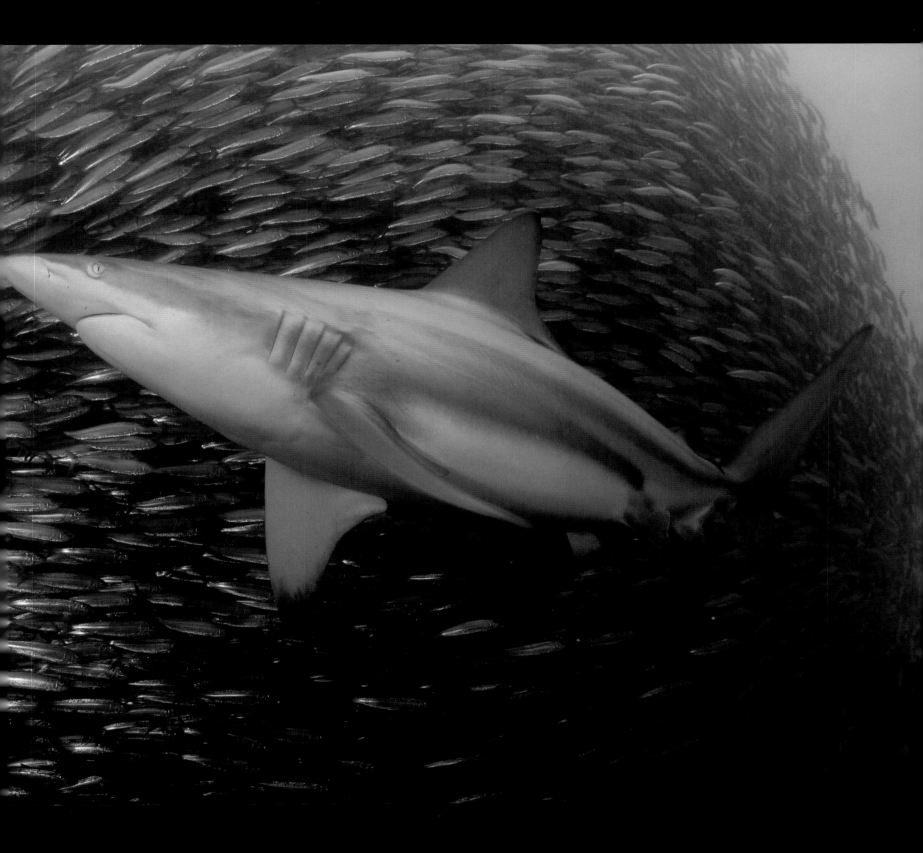

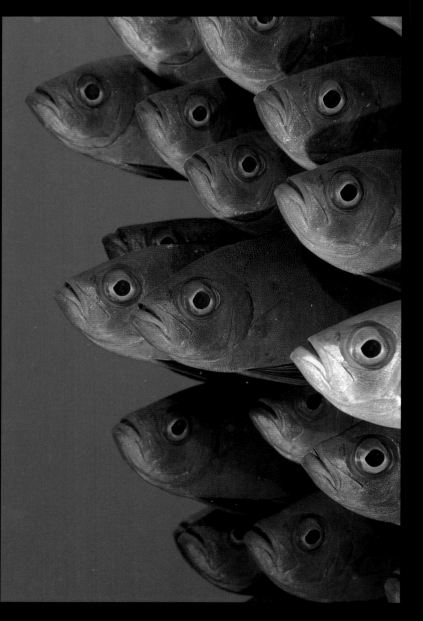

Barbara Karen Evans
South Africa

SCHOOL OF CRESCENT-TAIL BIGEYES

Floating over a reef off southern Mozambique, I saw a large, dark shape coming towards me out of the blue. As it approached, I realised it was a school of crescent-tail bigeyes, the individuals packed tightly together. Admiring how well the shoal must fool predators, I regretted not fitting my wide-angle lens, which I could have photographed the whole scene with. Slowly, holding my breath so as not to scare the bigeyes away with my bubbles, I got close enough to photograph the pack's leaders. Red is one of the first colours to be absorbed under water, and so I didn't realise at the time just how red these fish really were. The resulting picture was a pleasant surprise.

Nikon 801 with 60mm macro lens; 1/60 sec at f8; Fujichrome Velvia; Subal housing; 2 Nikonos SB105 strobes.

Charles Hood
UK

GREAT HAMMERHEAD

We 'chummed' the shallow waters of the North Bahamas with waste mackerel guts and blood, hoping to attract the solitary great hammerhead – the shark that almost all other sharks fear. When this three-metre individual approached, I found that if I remained motionless in the water, near the stern of the boat, the shark would swim straight towards me, following the line of scent. The hammer-shaped head (cephalofoil) may maximise the area of sensory organs and help the shark 'scan' for food. Because there wasn't any actual food in the water, the shark stayed very calm and never once looked threatening.

Nikon D100 with 28mm Nikkor lens; 1/90 sec at f8; digital ISO

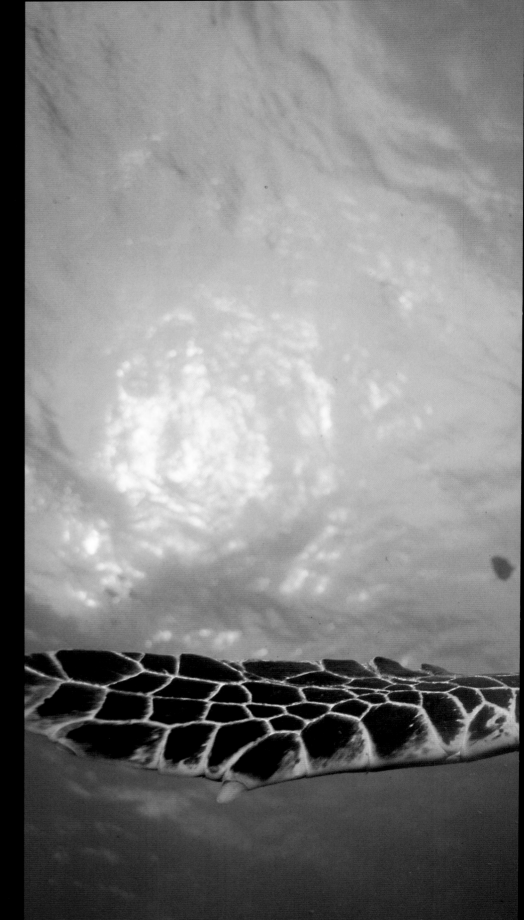

Harald Slauschek
Austria

HAWKSBILL TURTLE EATING SOFT RED CORAL

I encountered this hawksbill turtle at a reef drop-off in the southern Red Sea, and we drifted together along a light current. But then the turtle got entangled in sea whip (a horny coral with long, cylindrical filaments). I realised she needed help, and so I pushed the sea whip carefully aside, and we continued our drift along the reef together. The turtle then paused to eat a red soft coral, which gave me a wonderful opportunity to take a series of portraits showing its powerful beak, capable of biting off chunks of the hardest of coral. Even though hawksbills are endangered, they are still hunted for their shells as well as for food.

Nikon F90X, with 18-35mm lens; 1/125 sec at f8; Fujichrome Sensia 100; flash; Sea & Sea NX90Z housing; Sea & Sea YS120TTL flash.

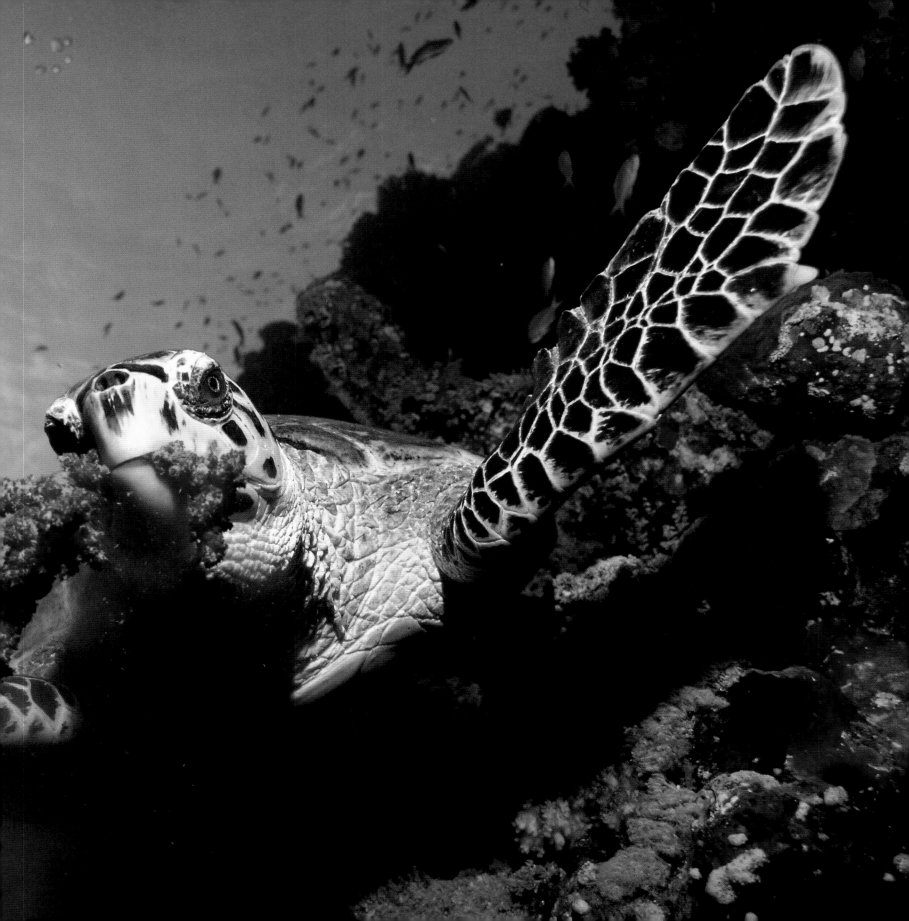

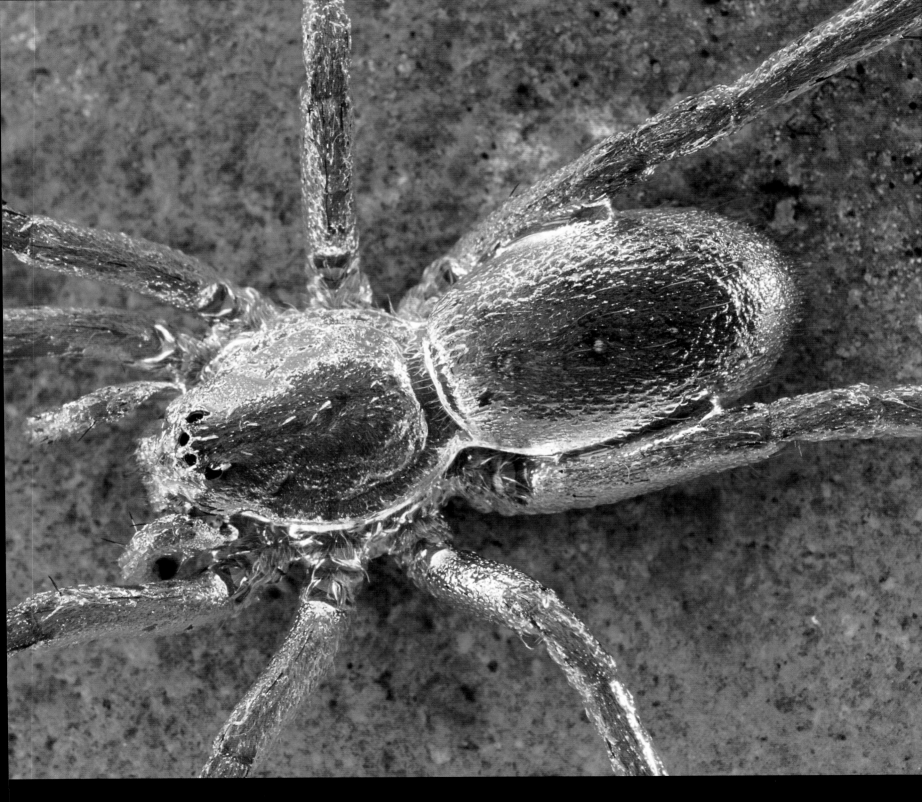

Brian Skerry
USA

**HARP SEAL PUP
LEARNING TO SWIM**
I photographed this pup off
Canada's Magdalene Islands,
where hundreds of thousands
of harp seals haul out to breed
and give birth. This was
probably the pup's first swim,
and it seemed especially
buoyant because of its thick,
white coat. Bobbing at the
surface for a while, it
eventually dived deeper.
Its mother was close by and
seemed to be watching her
pup's progress. It would have
been no older than three
weeks (its mother's rich milk
would have enabled it to triple
its birth weight in this time),
as it still had its white coat
(prized by the fur trade) –
camouflage for its days spent
on the ice. But very soon, it
would have begun to moult
into a 'ragged jacket' and then
a grey spotted adolescent,
ready for life at sea.
**Nikon F5 with 24mm lens; 1/60 sec
at f8; Kodachrome 64;
wide-angle strobe.**

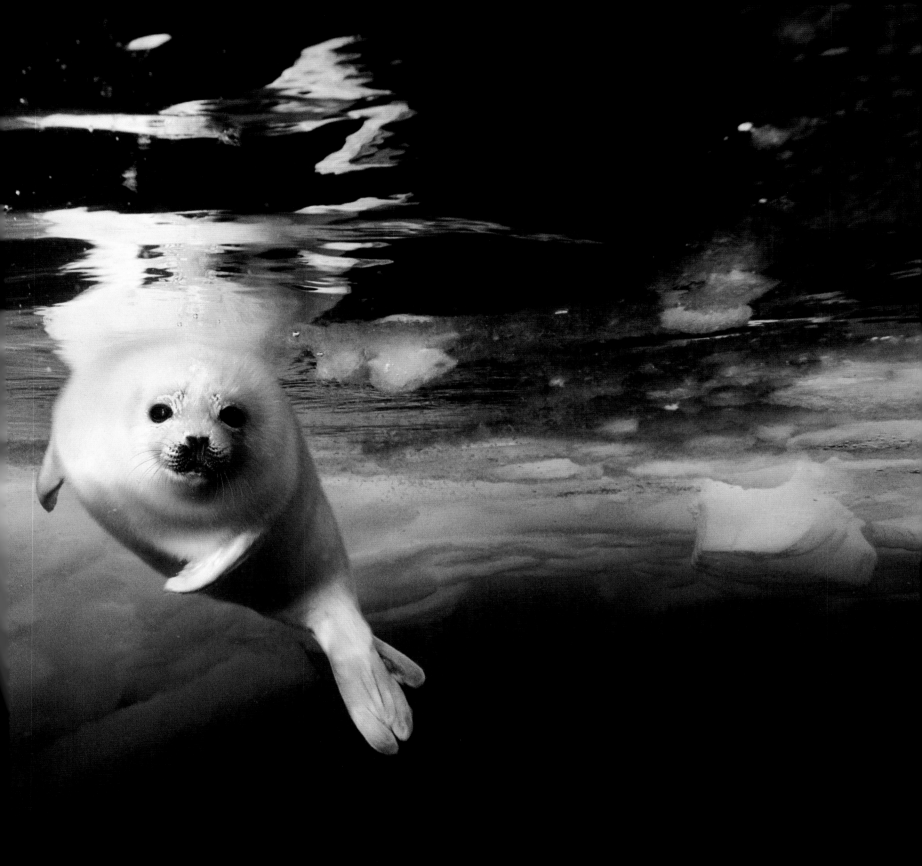

Animal portraits

This category — one of the most popular — invites entries that are true portraits, showing an animal in full- or centre-frame, which convey the spirit of the subject.

 WINNER

David Macri
USA

GREAT EGRET DISPLAYING

Male great egrets arrive before the females at this breeding colony in Florida. After selecting a nest site, a male sets about attracting a mate with intricate courtship displays comprising various stylised sequences including the 'stretch', 'wing preen', 'snap' and 'twig shake' displays. This male began his dance in a bowed, crouched position. He then quickly stretched his neck forward and upward in a fluid movement. He held that position for a few seconds, eyes to the sky, his aigrettes (breeding plumes) in full view for females gathered nearby to peruse.

Nikon F5 with Nikon 600mm f4 AF-S lens; 1/800 sec at f4; Kodak Ektachrome E100VS; Kirk Cobra head.

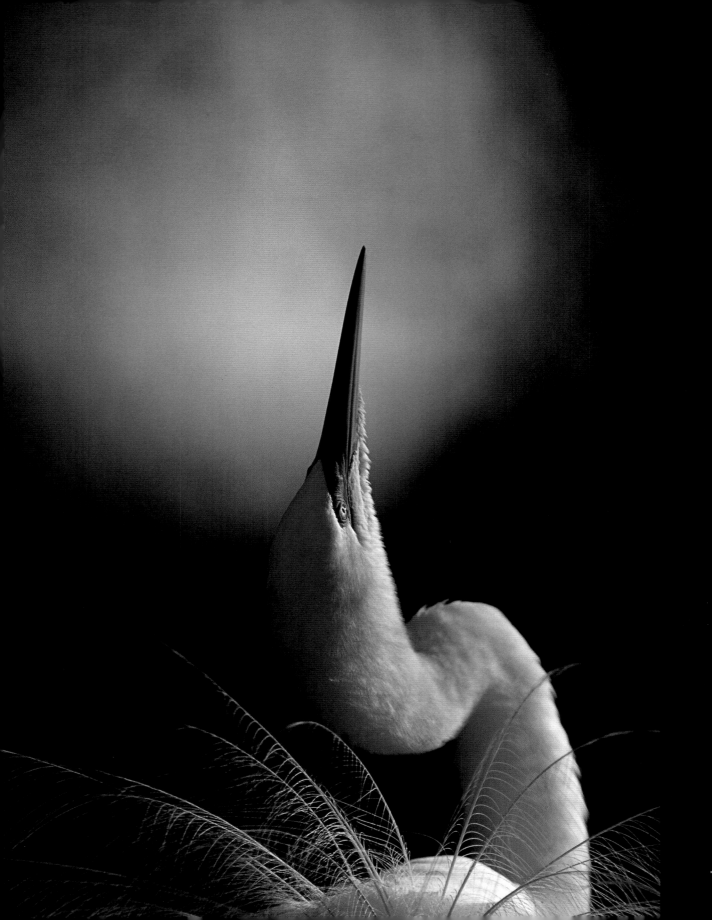

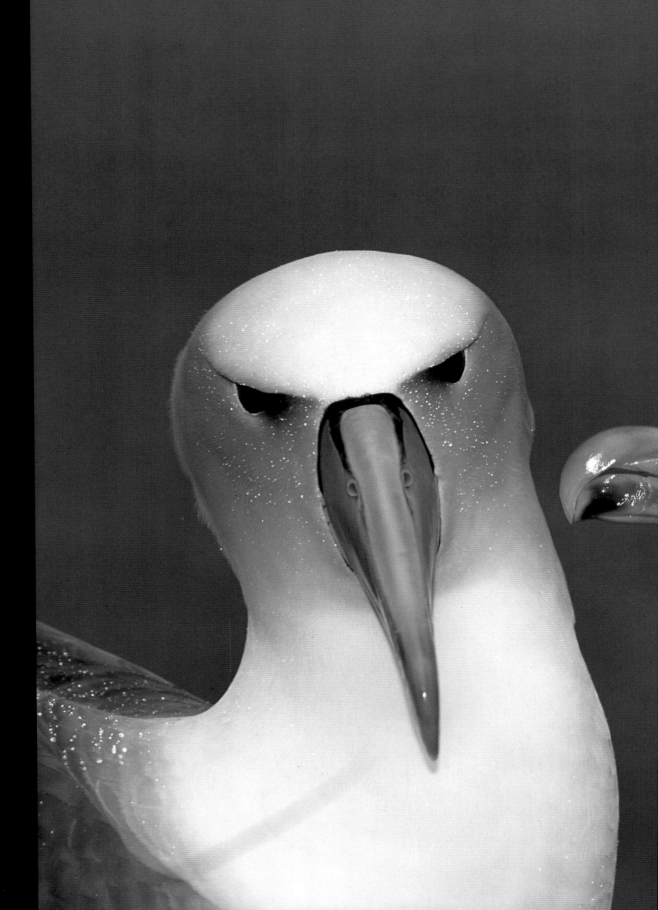

★ **RUNNER-UP**

Tui De Roy
New Zealand

**COURTING
WHITE-CAPPED
ALBATROSSES**

Overlooking the Southern
Ocean from their cliff-edge
perch on Auckland Island,
New Zealand, these
white-capped albatrosses
were totally engrossed in
tender preening and crooning
courtship rituals. They were
oblivious to the wind and
drizzle – and to my presence.
To get there, my partner and
I outfitted our own yacht and
spent four months exploring
these islands. I camped among
the weather-beaten tussock
grass near the colony, but
even in such a wild setting, the
birds aren't safe: I saw a feral
pig devour a fluffy albatross
chick on a nearby nest, and at
sea, adults fall victims to
longline fishing gear.
The knowledge of their
vulnerability made me savour
even more deeply the profound
peace that this devoted pair
exuded to one another.

**Nikon F5 with a 300mm lens;
1/250 sec at f2.8-f4.5; Fujichrome
Provia 100; flash with fresnel lens.**

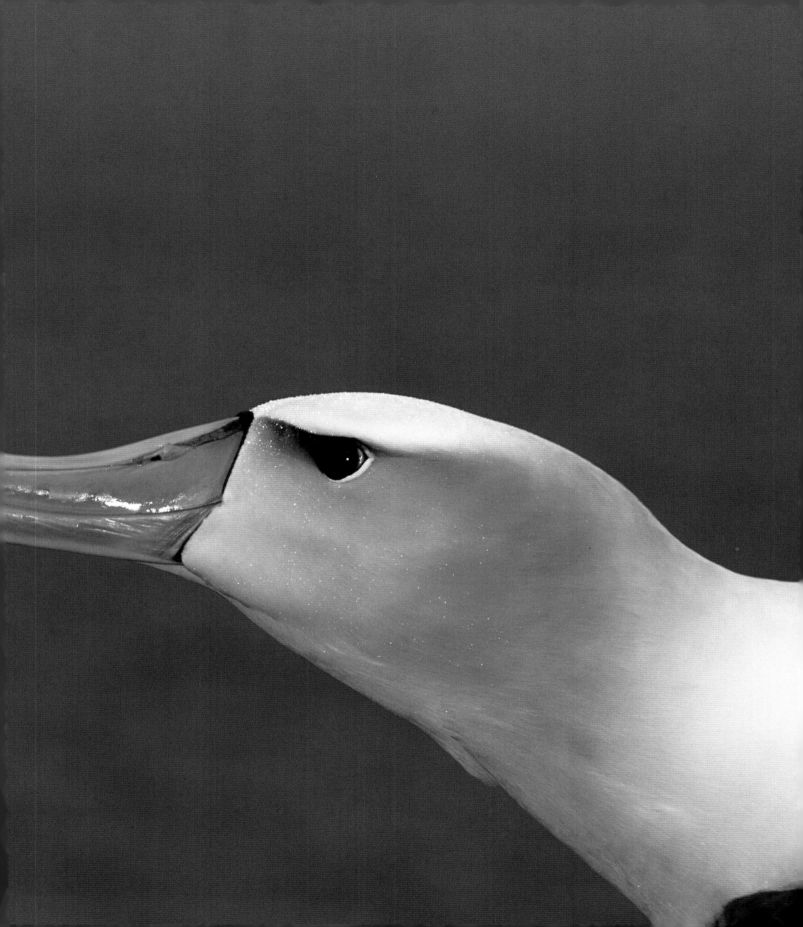

 SPECIALLY COMMENDED

Tore Hagman
Sweden

GREAT RAFT SPIDER
I came across this raft spider in Komosse, one of the largest peat bogs in southern Sweden. The area is protected as a Ramsar site, representing a special natural wetland in the European boreal region. The spider is spectacular – beautifully patterned and large (females have bodies more than 2cm long and a leg span up to 7cm), capable of catching large insects, small fish, tadpoles and even small frogs. The perfect setting for the magnificent creature was provided by an iron ochre sheen on the water. My biggest problem was that, the longer I spent trying to compose the perfect picture, the deeper my tripod and I sank into the quagmire.
Pentax 645 with 120mm macro lens; Fujichrome Velvia 50.

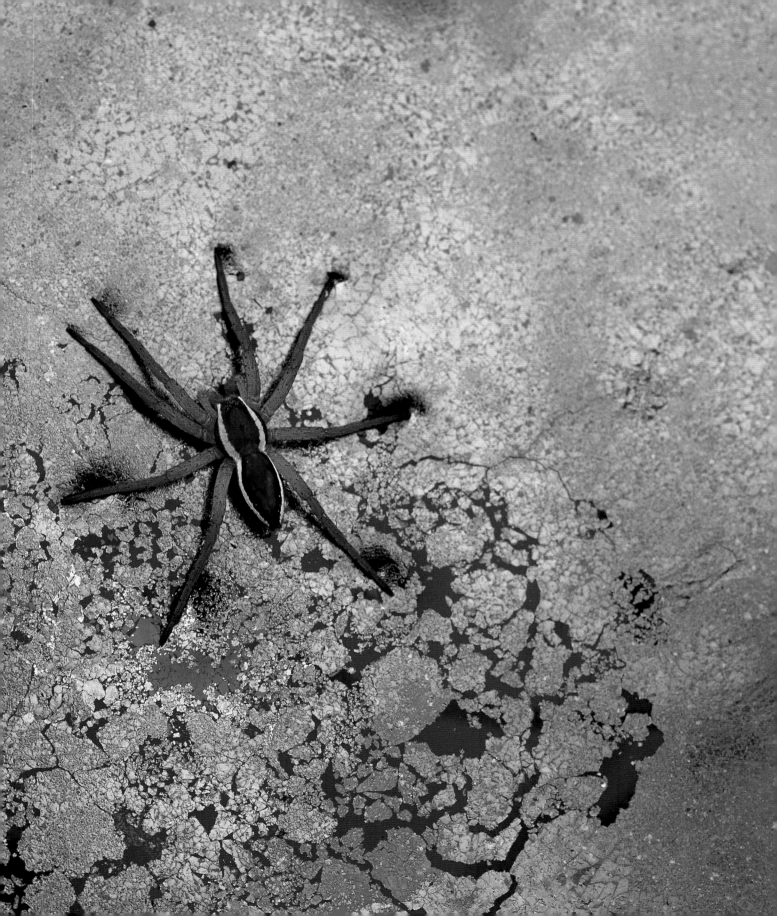

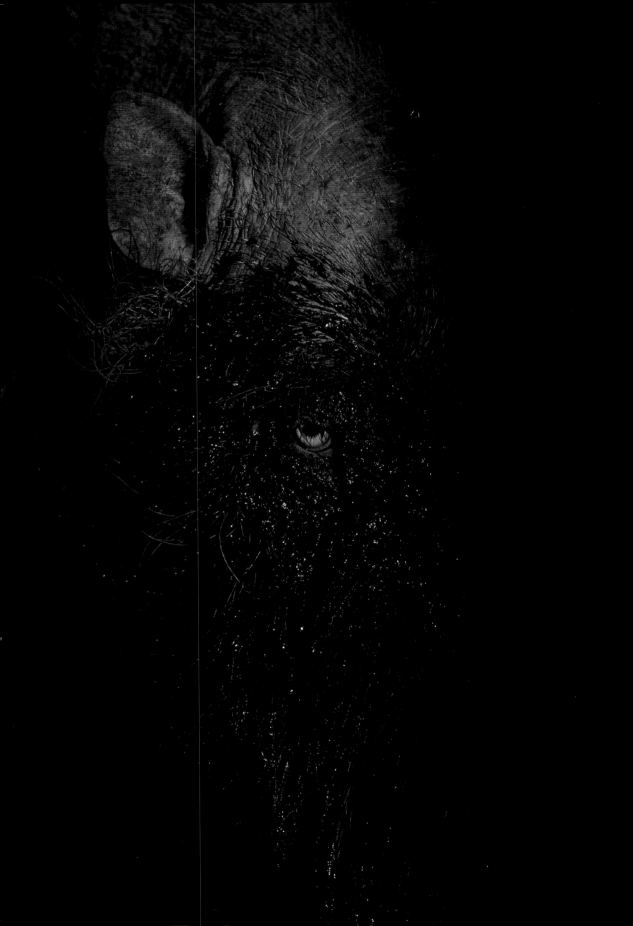

Stefano Unterthiner
Italy

BEARDED PIG

Evenings are a good time to watch bearded pigs in Sarawak's Bako National Park on the island of Borneo. I photographed this boar returning from a mud wallow one late afternoon, just as a beautiful light filtered through the forest canopy. In Bako, bearded pigs are quite common, but almost everywhere else (on Malaya and Sumatra, as well as Borneo) they are decreasing. Groups often follow gibbon families or macaque troops, feeding on the fruits that fall to the ground. They also undertake an annual migration (the only members of the pig family to do so). Migrating herds, led by an old male, may number more than a hundred individuals, travelling at night on paths that have probably been used for centuries.
Nikon F5 with 300mm lens; 1/160 sec at f5.6; Fujichrome Provia 100.

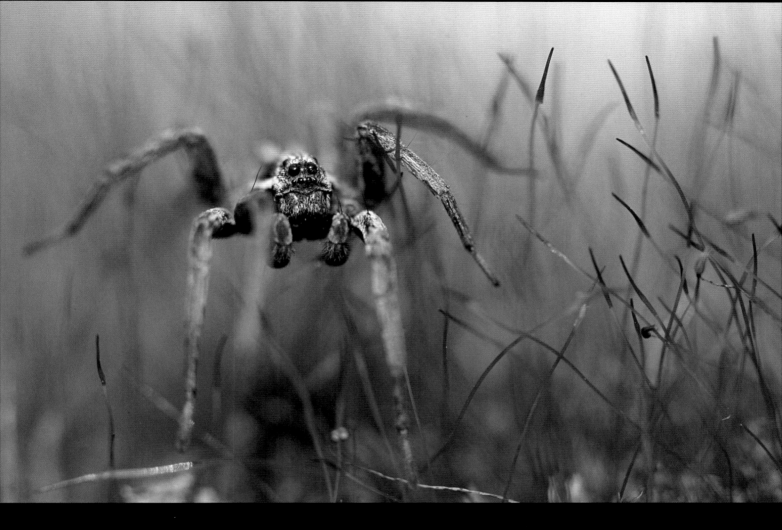

HIGHLY COMMENDED

József L Szentpéteri
Hungary

WOLF SPIDER
On a bright spring morning, I was lying on the ground in beautiful grassland, taking photographs of pasque flowers. Out of the corner of my eye, I spotted a sudden movement and saw a wolf long, lanky legs, it clambered across the grasses at an extraordinary speed. I spent the next half hour trying to keep up with it. The spider finally paused between some clumps of moss, and I managed to position myself face to face.
Canon EOS 1V with 100mm macro lens and extension tube; auto exposure at f2.8; Fujichrome

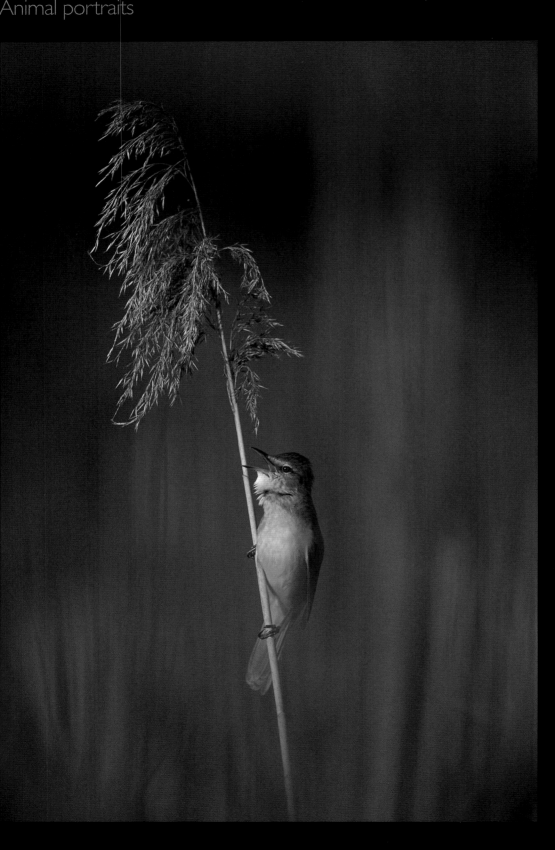

Marco Marangoni
Italy

GREAT REED WARBLER

In spring, I always look forward to the return of the great reed warblers and the sound of the males' unmistakable song. They are long-distance migrants that overwinter in Africa and return to Europe to breed. The males use their intense song to try to attract as many females as they can to nest in their territories, and on average, 40 per cent of males manage to persuade at least two females to do so.

This male's territory was at the edge of a reedbed in La Tomina in the province of Modena, Italy. Once I had identified where he was likely to roost, I set up my hide and waited. Here he is perching on one of the tallest reeds in his territory, proclaiming himself as owner. The sunset light provides the magic touch to the picture.

Canon EOS 1V with 600mm lens; 1/125 sec at f5.6; Fujichrome Provia 100.

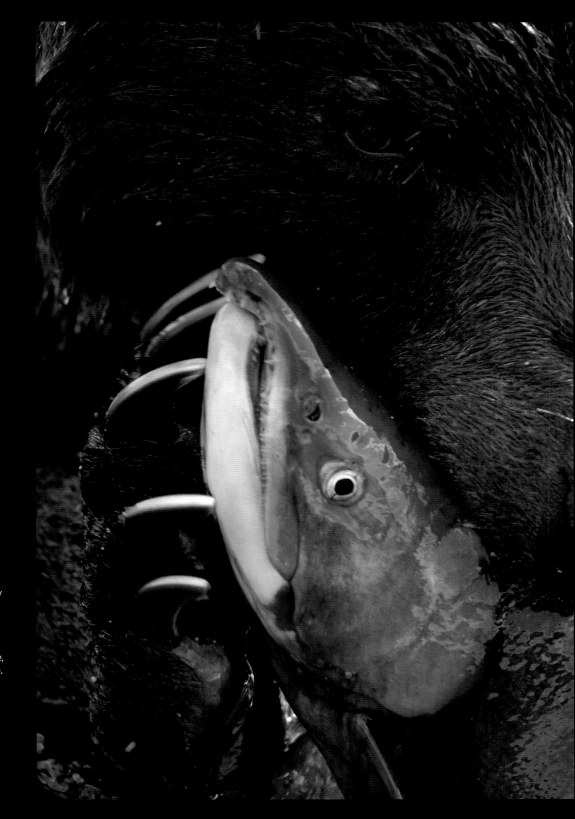

Klaus Nigge
Germany

BROWN BEAR FEASTING ON SALMON
I visited Kamchatka in the Russian Far East specifically to photograph bears. Near my house, I was lucky to have a salmon spawning ground, which was a magnet for the bears. Over the days, the bears got very used to me, allowing me to get quite close. Here, the bear has just emerged from the water with a male salmon, still alive. I caught the essence of that special moment by reducing the frame to focus on the bear's eye and claws and the eye of the fish.
Nikon D1 with 400mm f2.8 lens; 1/250 at f4; digital ISO 160.

This category aims to showcase the beauty and importance of flowering and non-flowering plants, whether by featuring them in close-up or as an essential part of their habitat.

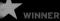
WINNER

Bernard Castelein
Belgium

BEECHWOOD WITH WILD GARLIC AND BLUEBELLS

Panoramic pictures don't have to be taken in exotic locations to be spectacular. In mid-April, the Hallerbos woodland south of Brussels in Belgium is carpeted with bluebells and wild garlic. In some spots, it's the combination of both species that is so beautiful, while in others, it's the sheer abundance of one that's so appealing. I spent some time considering how to compose an image, finally choosing soft light on an overcast day when the leaves of the beech trees were slightly unfurled.

Hasselblad XPan with 45mm lens; at f22; Fujichrome Velvia 50; tripod; cable release

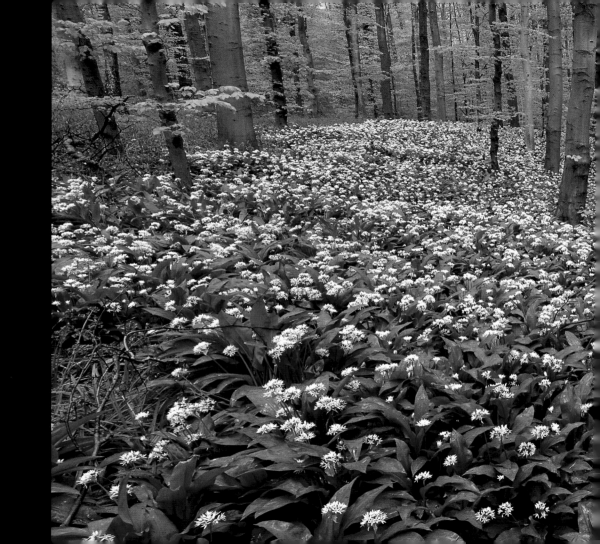

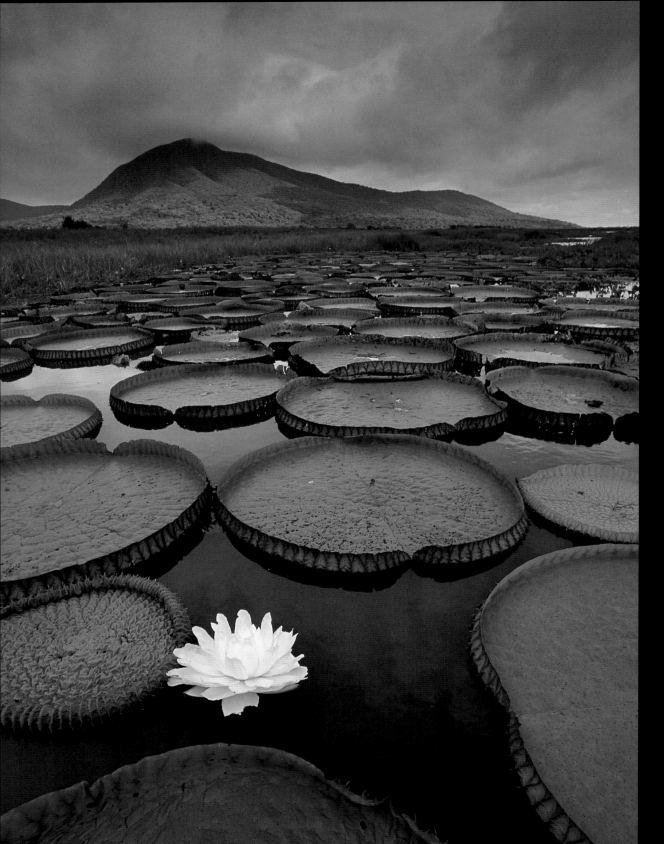

HIGHLY COMMENDED

Theo Allofs
Germany

GIANT AMAZON WATERLILIES

In the Amazon basin, this, the world's largest waterlily, blooms for just two days. On the first night, the flower opens, attracting beetles with its scent, pure white colour and warmth (the flower actually heats up). Later that night, the flower closes, trapping the beetles inside but providing them with food. Gradually it changes colour from white to pink to purple. On the second night, pollen is released onto the beetles, the flowers open and the beetles fly off looking for another warm flower, which they will pollinate. The first flower then closes and sinks. When I was photographing the flowers in the day, fish would jump up to nibble at the petals, which made it difficult for me to find an intact flower, even early in the morning. I returned for nine days to the same lagoon, in the western region of Brazil's Pantanal wetlands, before I finally got the shot I wanted.

Canon EOS 1V with Canon 20mm f2.8 lens; f16; Fujichrome Velvia 50; split neutral density filter.

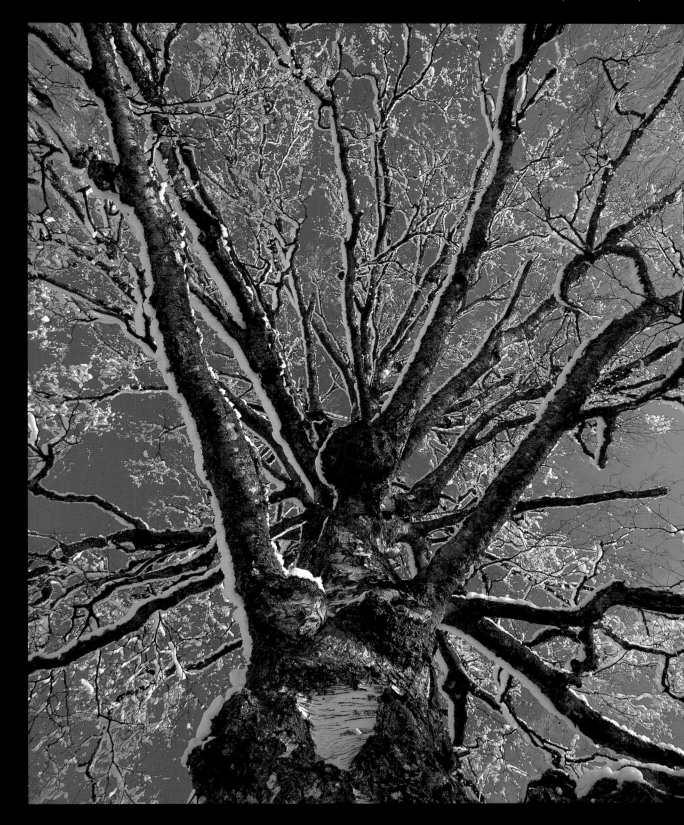

Melker Blomberg
Sweden

BIRCH TREE

Birch trees were among the first plants to recolonise the rocky, ice-scoured land in the wake of the huge glaciers of the last Ice Age. In early Celtic mythology, this pioneer species symbolised renewal and purification. As one of the first trees to come into leaf, birch also represents spring. It has strong fertility connections with the celebrations of Beltane, the second half of the Celtic year (May Day) and with the Norse deities Frigga and Freya, goddesses of love and fertility. I discovered this great tree at Badelunda near Vasteras, central Sweden. As the poet Coleridge wrote of the birch, this was a true "Lady of the Woods."

Mamiya RZ 67 with 50mm lens; f16; Fujichrome Velvia; polarising filter; tripod.

Balázs Kármán
Hungary

HERALD OF SPRING

The rare cloth-of-gold crocus is the first flower to appear, in glorious, golden masses in the smaller, uncultivated fields of the Great Hungarian Plain, not far from my home. For my first shots this year, I decided to concentrate on this group of flowers closing in the cold rain to protect their pollen, highlighting them with a small spotlight and using a filter to enhance the bluish surrounds. The spring flowering of these wild crocuses heralds for me the start of my nature photography season.

Canon F1N with 100mm f4 macro lens; 1 sec at f16; Fujichrome Velvia 50; spotlight; blue filter.

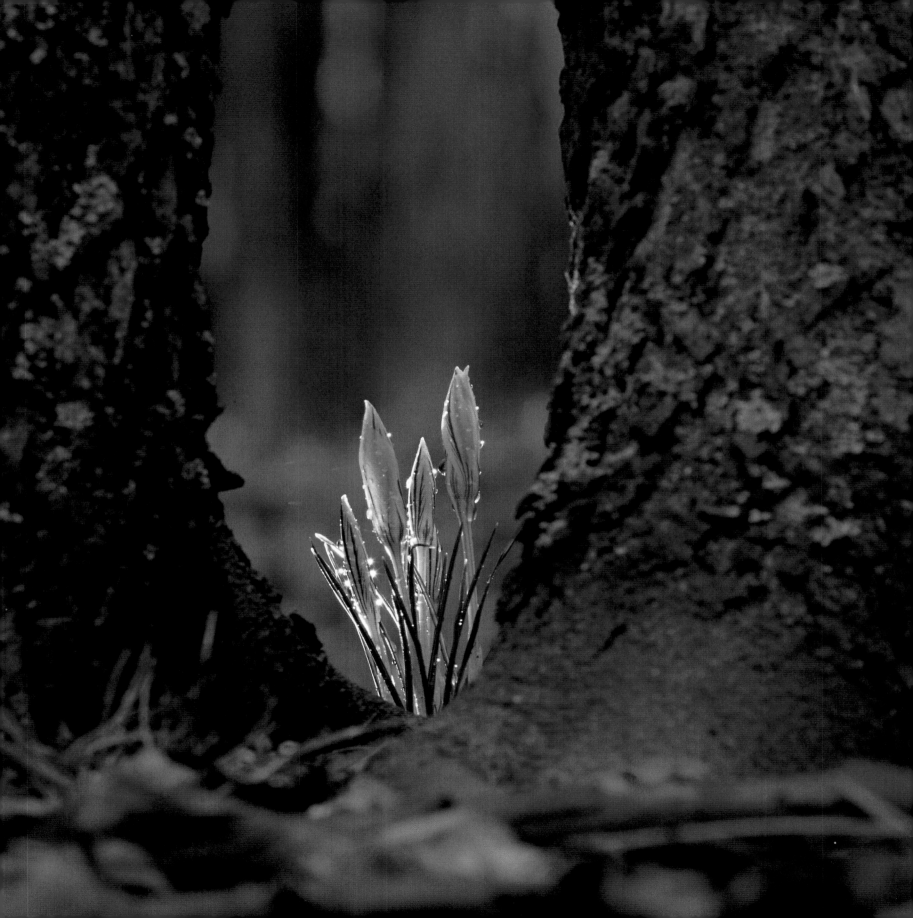

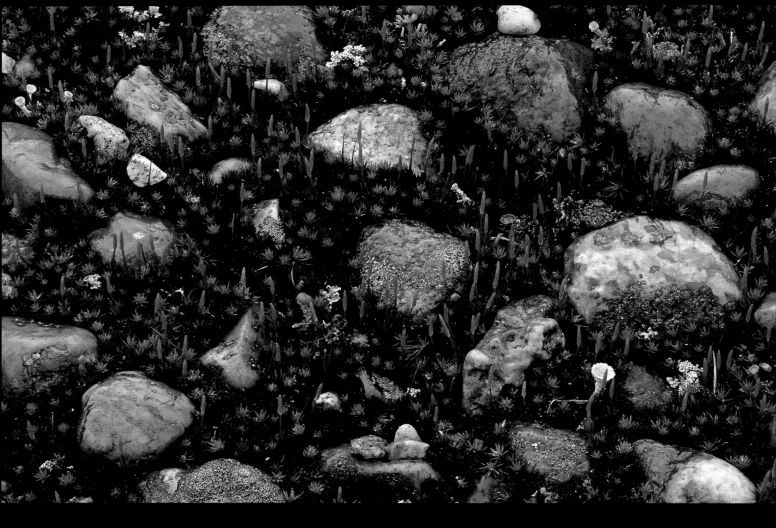

Jesper Tönning
Denmark

MOSS AND STONES

Anholt is Denmark's most isolated island, situated in the sea of Kattegat off Jutland. It has just 150 inhabitants, and nearly all of its 22 square kilometres are designated as an area of outstanding natural beauty, mostly because of the 250 or so species of lichen you can find out on the moors. I discovered this beautiful pattern of moss, lichens and pebbles on a wet, cold day in February. The soft light created by the dull weather gave me the saturated colours I wanted, and the wet stones made the image sparkle.

Nikon F5 with 85mm f2.8 micro lens; 1 sec at f22; Ektachrome 100 VS; tripod.

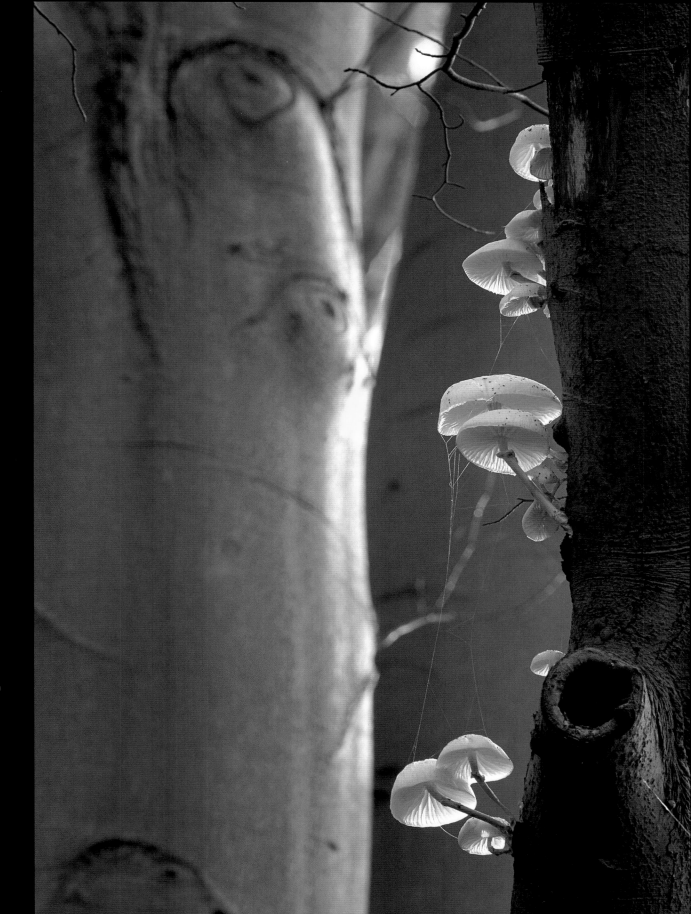

HIGHLY COMMENDED
Danny Beath
UK

PORCELAIN MUSHROOMS
Translucent porcelain mushrooms, among the loveliest agaric fungi, appear in autumn on dead beech tree trunks and fallen branches and occasionally on living trees. These were sprouting from a dead branch of a beech on Nesscliffe Hill in Shropshire. The following week, I returned to the tree on a stormy afternoon, waited a couple of hours until the clouds broke briefly and the sun flashed across the sky and managed to take three shots before the light went dull again and it began to rain. The tree blew down a short time later.
Nikon FE2 with Sigma 70-300mm APO lens; 1/15 sec at f5.6; Fujichrome Velvia 50; tripod.

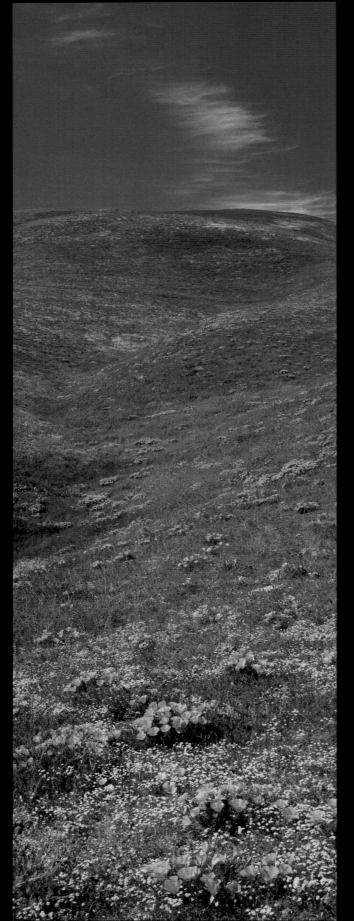

Florian Schulz
Germany

CALIFORNIAN WILDFLOWER MEADOW

When I arrived in the foothills of the Tehachapi Mountains in southern California, they were covered with wildflowers – purple lupins, California poppies, coreopsis, cream cups, goldfields and owl's clover, to name but a few of the blooms that created the spectacular sea of colour and fragrance. I visited the area specifically to photograph the flowers and was lucky because plentiful winter rains had helped ignite the display – the best in years. The use of a portrait format helped emphasise the rolling hills, and the blue sky provided a perfect contrasting backdrop.

Fujinon GX617 with 180mm lens; 1/15 sec at f32; Kodak E100VS.

Alf Linderheim
Sweden

SHAGGY INK CAPS

These shaggy ink caps, growing on a lawn near my home in central Sweden and looking like miniature trees, captivated me. I kept an eye on them for a few days, waiting until they were fully developed and some were deliquescing after having shed their spores . Taking this shot was such a luxury – the antithesis of my normal nature photography, which usually involves being eaten alive by mosquitoes in a Swedish forests or on a bog.

RolleiFlex SL66SE with 50mm lens; 1/2 sec at f22; Fujuichrome Velvia 50; tripod.

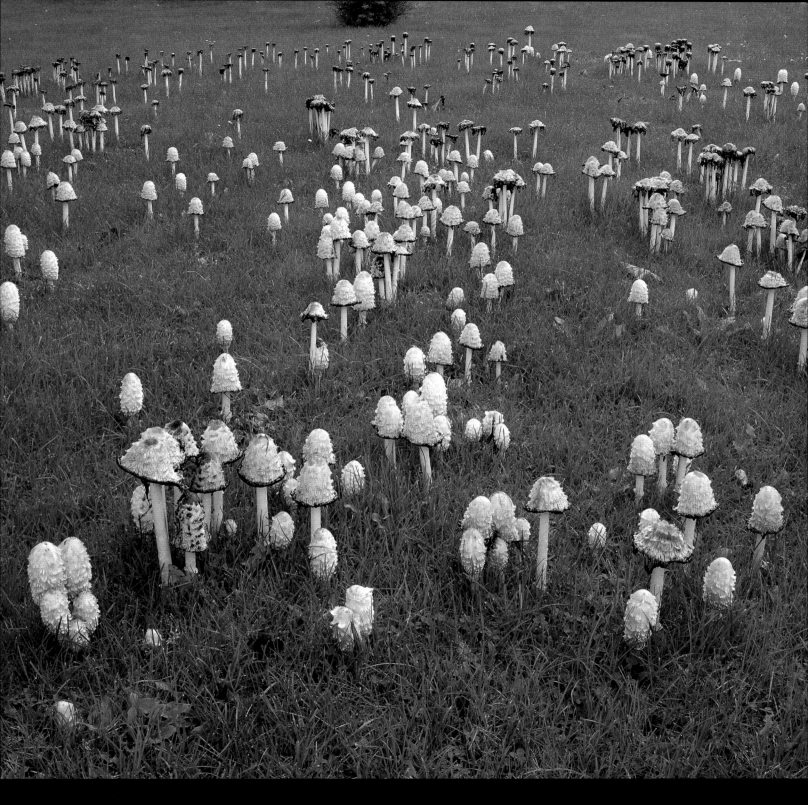

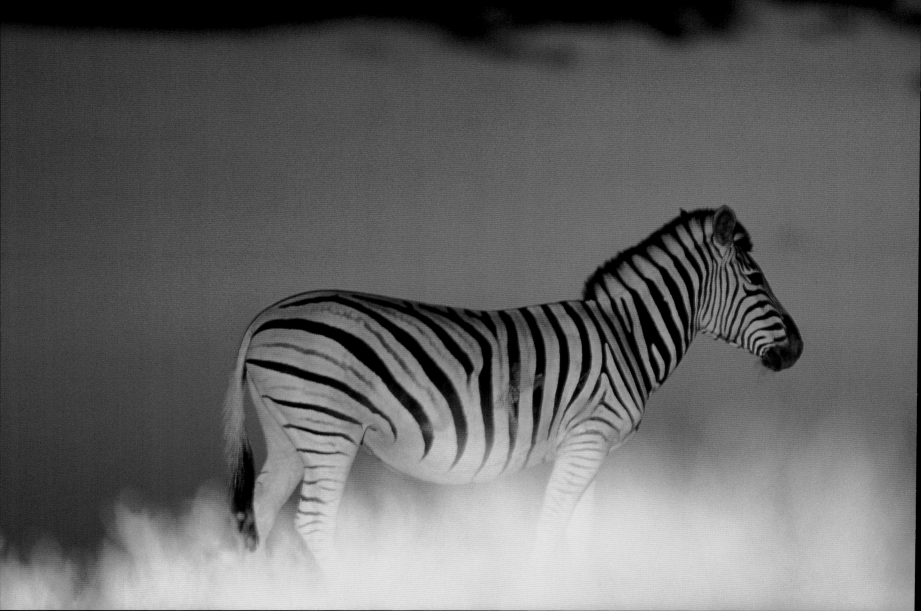

From dusk
to dawn

The criterion for this category is strict: the wildlife
must be photographed between sunset and sunrise,
and the sun may be on but not above the horizon.

 WINNER

Peter Lilja
Sweden

ZEBRA AT DUSK
One evening, when I and
a friend were heading out of
Etosha National Park in
Namibia, we drove past a herd
of zebras standing peacefully
by the side of the road.
We swung the car round so
that it faced the zebras, with
the deep orange sky forming
a dramatic backdrop, and
I opened the car door as
quietly as I could and put the
beanbag on the ground, so
that I could photograph one of
the zebras at a low angle.
I switched on the headlights,
and the beam lit up the dry
grass in the foreground as
though it was on fire.
**Nikon F5 with 300mm f2.8 Nikkor
lens; 1/20 sec at f2.8; Kodak
Ektachrome E100VS; beanbag.**

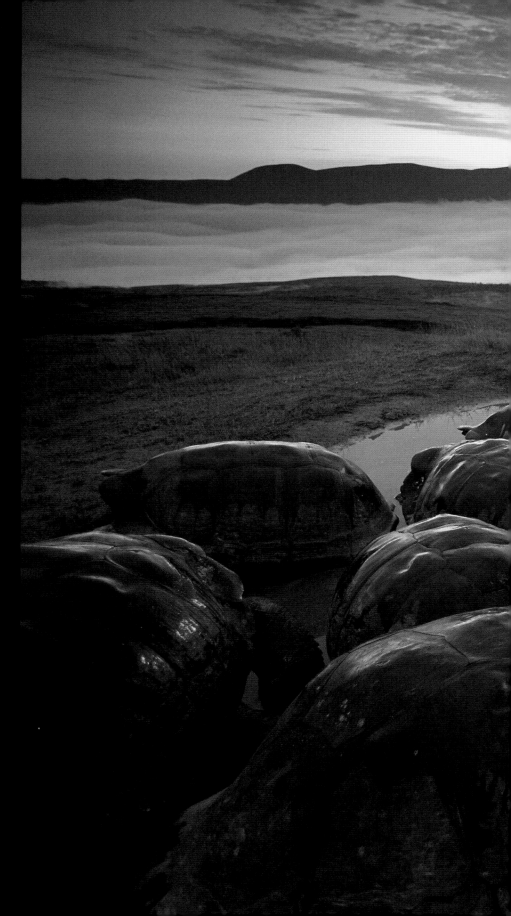

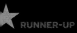 RUNNER-UP

Tui De Roy
New Zealand

GALAPAGOS GIANT TORTOISES AT DAWN

A classic scene in a world where ancient reptiles still freely roam. This group of males had spent the night in the mud wallow – possibly seeking relief from ticks – and were beginning to stir as the mist rose from the caldera below them. It was the end of the rainy season, their most active period, and they would be spending the day grazing and mating. Isabela Island is perhaps my favourite place in the world. It's where I cut my teeth as a photographer 1 years earlier. I returned recently to document the state of affairs of the largest remaining giant tortoise population in the Galapagos. Though a massive feral goat population, competing with the tortoises for food, has devastated the landscape the giants are resilient and have endured the onslaught. Now a joint project run by the Galapagos National Park and the Charles Darwin Foundation has mobilised a multi-million-dollar campaign to eliminate the goats.

Nikon F5 with 18mm lens; Fujichrome Provia 100; fill-flash with diffuser box; tripod.

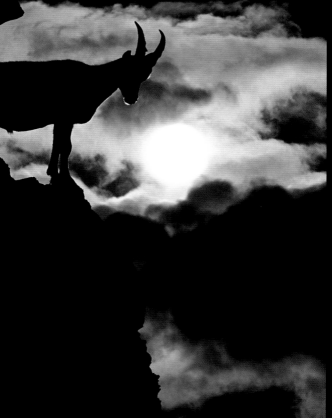

HIGHLY COMMENDED

Steven J Kazlowski
USA

POLAR BEAR FEEDING ON A WHALE CARCASS
This carcass of a young bowhead whale, on a beach within the Arctic National Wildlife Refuge of Alaska, provided food for a number of polar bears for several days. I managed to position myself at eye-level to this bear just three metres away by arching my body through the window of a friend's truck, trying to ignore the stench of rotting flesh. The bear didn't seem bothered by our presence and continued to feed, breathing heavily. Several others joined it, and the sound of roaring and tearing filled the cold night air as their jaws ripped through the whale flesh. **Nikon N90-S with 28mm-70mm lens; 1/125 sec; Fujichrome Sensia 100; SB-25 flash.**

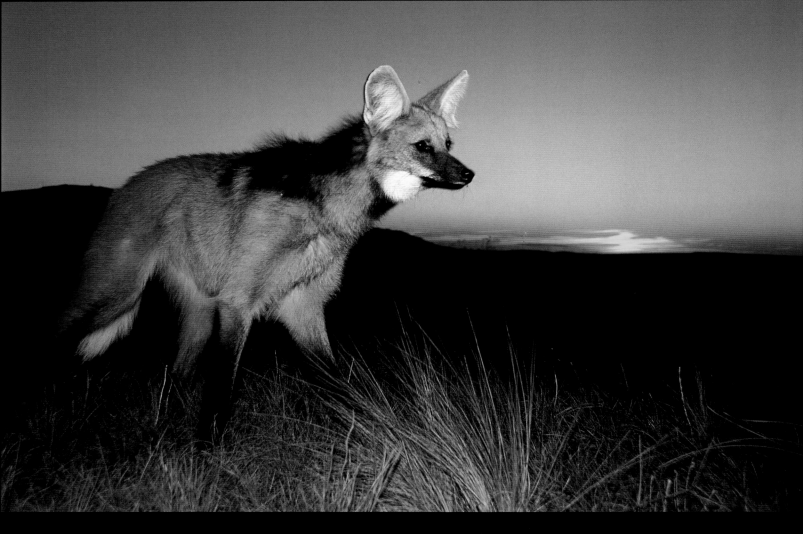

Luiz Claudio Marigo
Brazil

MANED WOLF AT SUNSET

We set out to search for maned wolves on the *cerrados* (grasslands) of Serra da Canastra National Park in south-east Brazil. When we spotted this female, we began to follow her on foot, keeping a respectful distance so as not to scare her. It didn't take more than a couple of days for her to became quite used to my wife and me. I took this shot at the top of a hillock at dusk at about two metres away. We found her both intelligent and fascinating, always inquisitive about her surroundings and strangely graceful as she stalked her prey on those long, stilt-like legs. Four months later, there were grassland fires, and we never saw her again. I don't believe she died in the flames – she was too clever and quick – but she would have had to find a new territory.

Nikon F5 with 24-85mm lens; 1/60 sec at f5.6; Fujichrome Velvia 50 rated at 80.

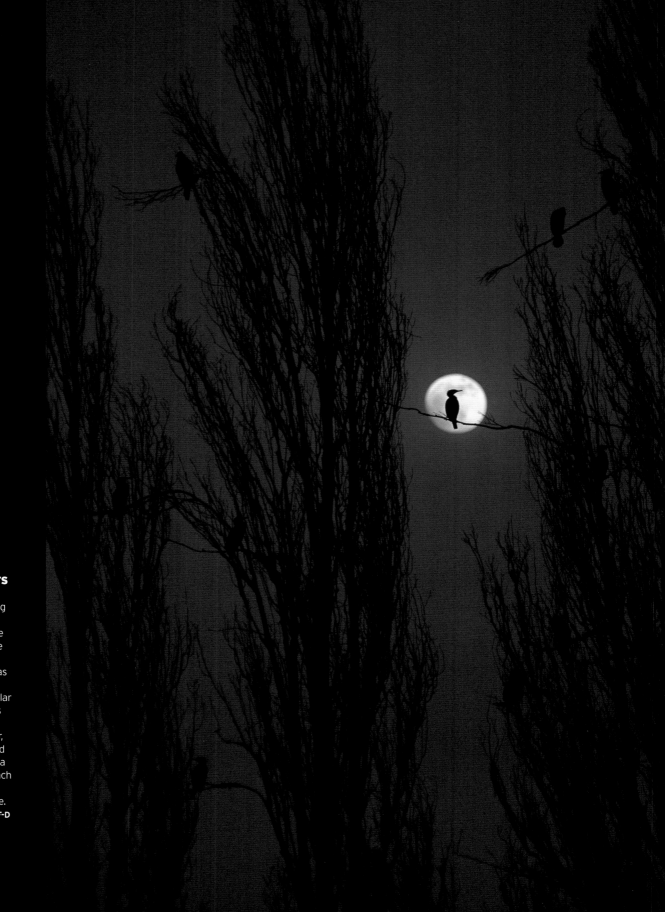

HIGHLY COMMENDED

Andrea Bonetti
Switzerland

ROOSTING CORMORANTS

I was driving home, having spent the day photographing Dalmatian pelicans and cormorants at Kastoria Lake in Greece when I noticed the full moon rising. I turned around and headed as fast as I could back to the lake and stationed myself by the poplar trees where the cormorants roost. The birds were there, but as the moon rose higher, I felt increasingly dissatisfied with the composition. Then a cormorant landed on a branch right in front of the moon – and the image was complete.

Nikon ED with Nikkor 80-200 EF-D f2.8 lens; 1/60 sec at f5.6; Fujichrome Sensia 100; tripod.

Composition and form

Here, realism takes a back seat, and the focus is totally on the aesthetic appeal of the pictures, which must illustrate natural subjects in abstract ways.

 WINNER

Larry Michael
USA

WIND-BLOWN SUGAR MAPLE
Autumn in Wisconsin always offers great opportunities for colour nature photography, particularly for creating abstracts. My students often complain if it's very windy during an outdoor workshop, but I encourage them just to go with the conditions and see what happens to their work. In this image of a sugar maple, Wisconsin's state tree, I let the wind paint the autumn colours on film during a

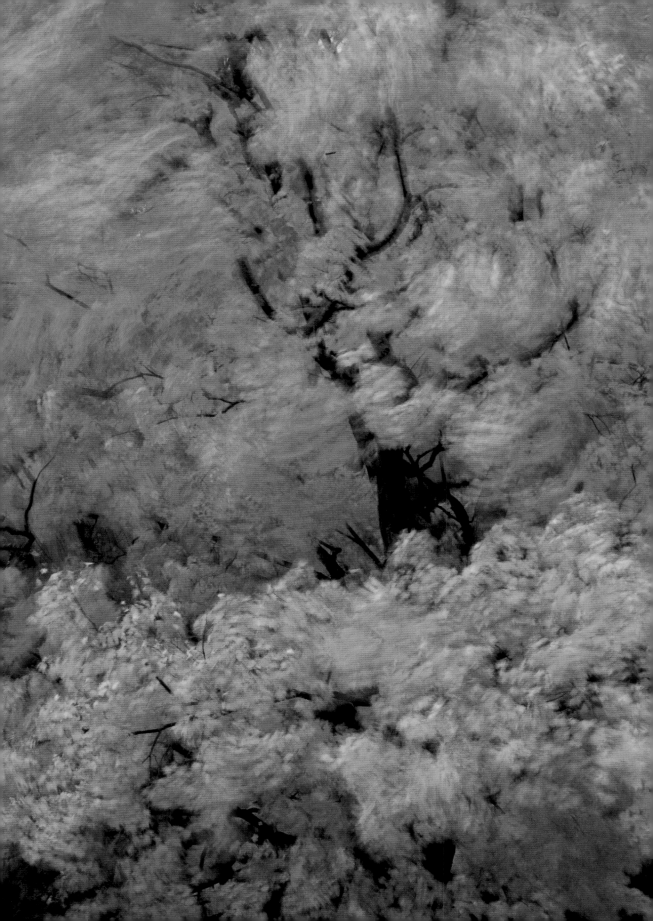

 RUNNER-UP

Ulf Westerberg
Sweden

ALGAE-CLAD ROCK AT TWILIGHT

I had spent the best part of a cold winter day photographing icicles and patterns of water in the warm evening light. When it was time to pack up, I noticed that reflections of the red sky had appeared in the rocky landscape around me. Suspecting this effect would not last long, I quickly searched for an interesting pattern and took one shot. A few seconds later, the light was gone and so was the magic.

Nikon F3 with Nikkor 28-105mm lens; 8 sec at f11; Fujichrome Velvia 50; Gitzo tripod.

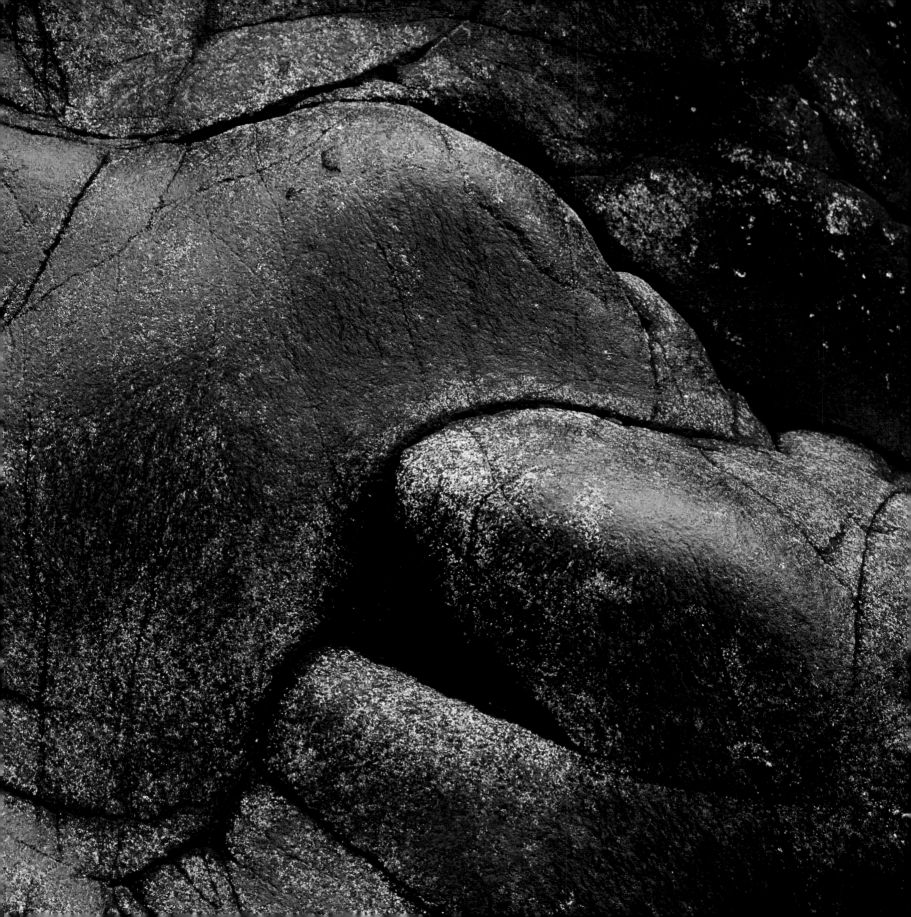

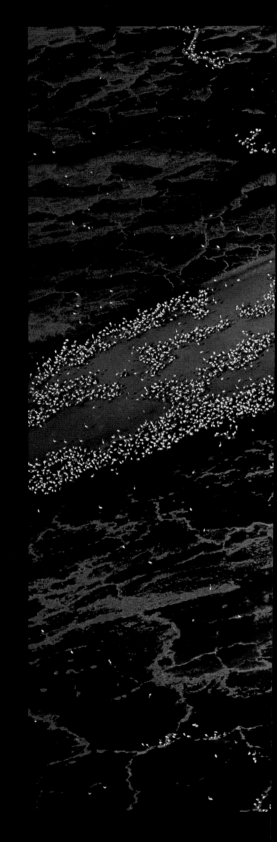

Jan Vermeer
The Netherlands

ROYAL ALBATROSS

The royal albatross has a wingspan of three and a half metres. It's a truly magnificent bird, particularly when it flies right past you. When it sits on its nest, though, it's not quite so impressive. I was on Campbell Island, in the Ross Sea, trying to photograph royals that were doing little apart from incubating their eggs, on nests some 100 metres or so apart. But it was precisely because this female was so inactive that I was able to succeed – with time on my side, I could let the composition and image grow.

Canon EOS 1Ds with 500mm lens; 1/320 sec at f22; digital ISO 200; Gitzo tripod.

Anup Shah
UK

LAKE NATRON AND FLAMINGOS

I was lucky enough to fly over the Lake Natron in Tanzania, a soda lake with a salt-crust surface stained by the red pigments of spirulina, the algae on which the millions of lesser flamingos in the Great Rift Valley feed and which provides the pink pigment in their plumage. Natron is one of the few sites in Africa where lesser flamingos manage to breed regularly, its unbearable heat, undrinkable water and unwalkable caustic mudflats offering safety from most predators. The swirling ribbons of pink in this picture are actually thousands of flamingos sitting on nests or feeding in the shallow lake.

Canon EOS 1V with 35mm lens; Fujichrome Provia 100.

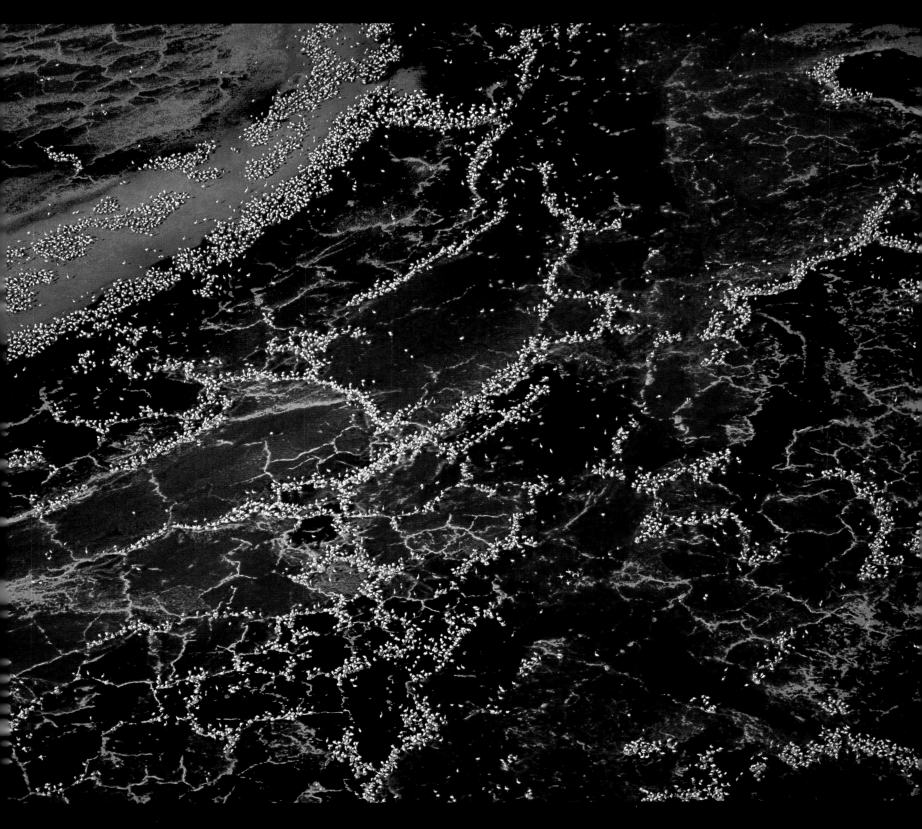

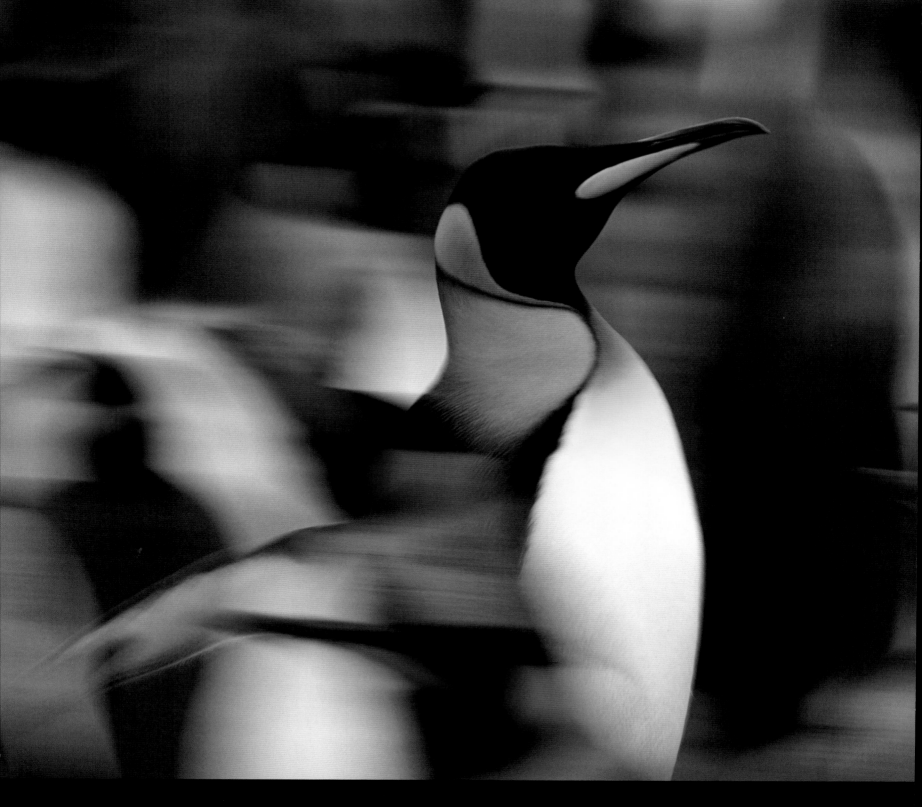

Theo Allofs
Germany

KING PENGUIN ON THE MOVE

There was never a moment's peace in the huge colony of king penguins at Salisbury Plains on the island of South Georgia. In the breeding season, both parents take turns, day by day, to feed their single chick, and so the traffic is constant, with hordes of penguins making their way towards the ocean to fish or heading busily back to feed their young. Some have to walk up to two kilometres – each way. If they jostled too close to adults incubating eggs on their feet, they risked getting a nasty peck. I wanted to capture one king penguin commuting through this colourful chaos, and this is the picture that did it for me.

Nikon F5 with Nikkor 600mm f4 lens; 1/15 sec; Fujichrome Velvia 50.

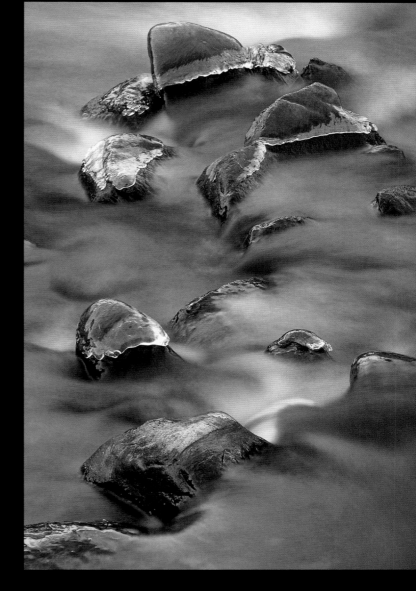

Hugo Wassermann
Italy

RIVER AT TWILIGHT

In winter, the river close to where I live (in the South Tyrol, Italy) becomes my second home. I spend endless hours there, trying to capture the light effects on film. I concentrate mostly on natural forms and details. One particularly cold evening, I saw that a thin layer of ice had formed on top of the rocks in the water. When I looked more closely, I could see that a nearby stone wall, covered in vegetation and bathed in soft light, was reflected in the water.

Canon EOS IV with 70-200mm f2.8 lens; 5 secs at f22; Fujichrome Velvia 50; tripod and Mirrow pre-release.

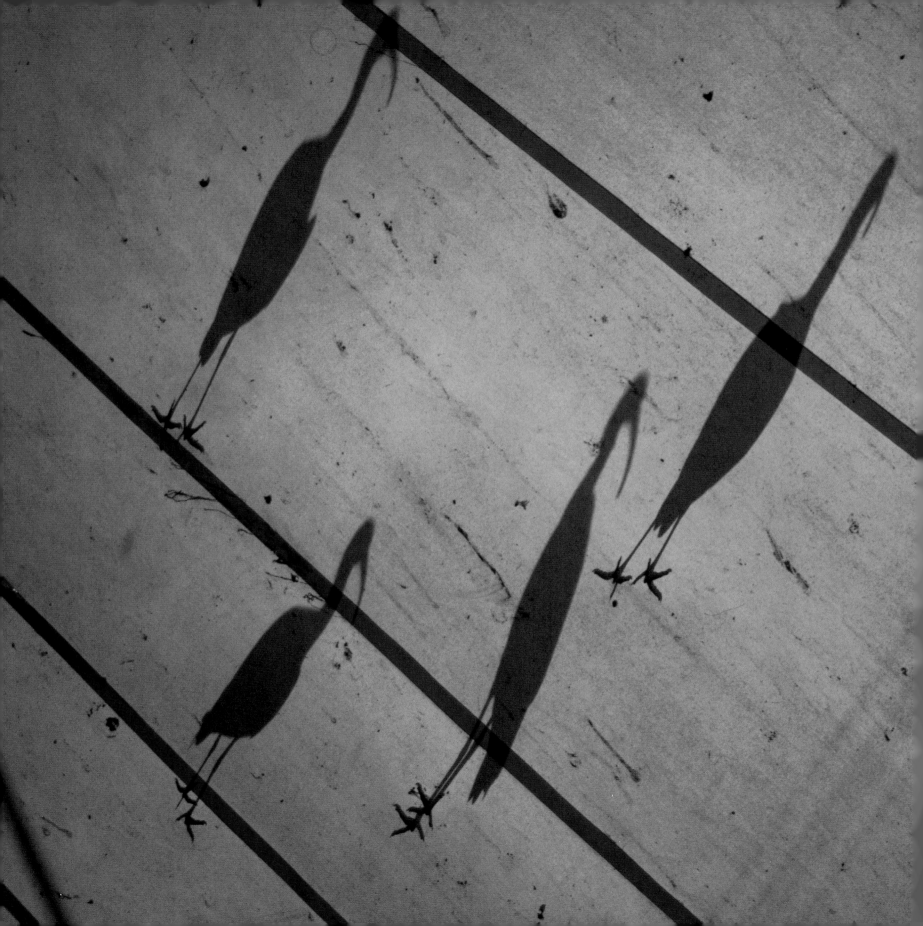

John Olsen
Australia

WHITE IBIS SHADOWS

This photograph was taken fairly early in the morning at Port Douglas, Queensland, Australia. While eating breakfast in a wildlife park, I noticed that Australian white ibis were landing on top of the overhead dome, presumably to enjoy the morning sun. The patterns continually changed as the ibis turned their heads, and the shadows of their long, curved beaks became longer or shorter depending on the angle to the sun. The diagonal lines of the joins in the translucent roofing material enhanced the drama of the birds' shadows.

Nikon F90X with 28-70mm lens; 1/125 sec at f5.6; Fujichrome Velvia rated at 40.

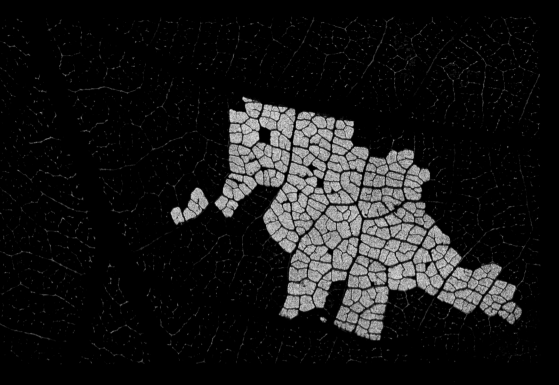

Gábor Kiss
Hungary

OAK-LEAF PICTURE

I often head for the Buda Hills, on the north-western outskirts of Budapest. The area is covered with a mix of woodlands, open meadows, rocky crags and scrubland. One day in September, when resting under a huge oak tree, I looked up and noticed that many of the leaves had suffered serious damage. The sun shone through the holes, creating fascinating, mosaic-like shapes such as this one – a cross between a dragon and an elephant. On investigating, I found that the holes were made by the tiny oak-leaf beetle.

Nikon F100 with AF Micro Nikkor 200mm lens; 1/15 sec at f16; Fujichrome Velvia 50 Dx; tripod.

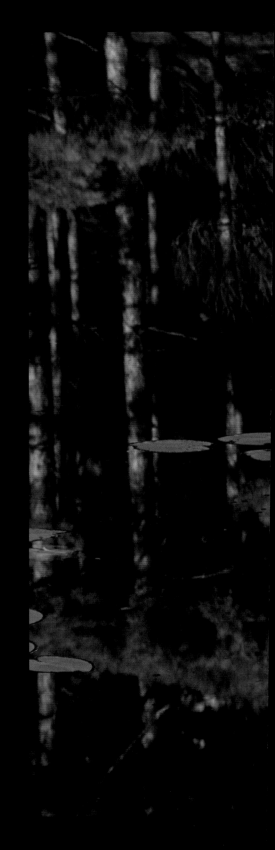

HIGHLY COMMENDED

Irene Greenberg
USA

LAKE REFLECTION AND LILY PADS

While wandering through the woods in Paradise, Michigan, I came across this pond. It was a very still morning, and the reflections of branches on the pond's surface were so pin-sharp and the reflected colours so rich and true that it looked as though the world had simply flipped upside down, leaving lily pads dangling in the middle of nothing.

Nikon F5 with Nikkor 24-120mm lens; Fujichrome Velvia rated at 50; Hoya 81B warming filter; Bogen 3221 tripod and Manfrotto 410 gear head.

Wild places

This is a category for landscape photographs, but ones that must convey a true feeling of wildness and create a sense of awe.

WINNER

Régis Cavignaux
France

ICELANDIC CLIFFS
In Jules Verne's book *Journey to the Centre of the Earth*, the heroes set off from inside the volcano Snaefells, on the west coast of Iceland. When I visited the wild, volcanic Snaefells peninsula, it rained for an entire week. As soon as blue sky appeared, I went to the coast intending to photograph kittiwakes taking off from the dramatic cliffs. But I became fascinated by the contrast between the rounded, foaming waves on black sand and the geometric, basalt rock columns, formed by lava from the now-extinct volcano.
Nikon F801 with 400mm lens; 1/1000 sec at f5.6; Sensia 100; monopod.

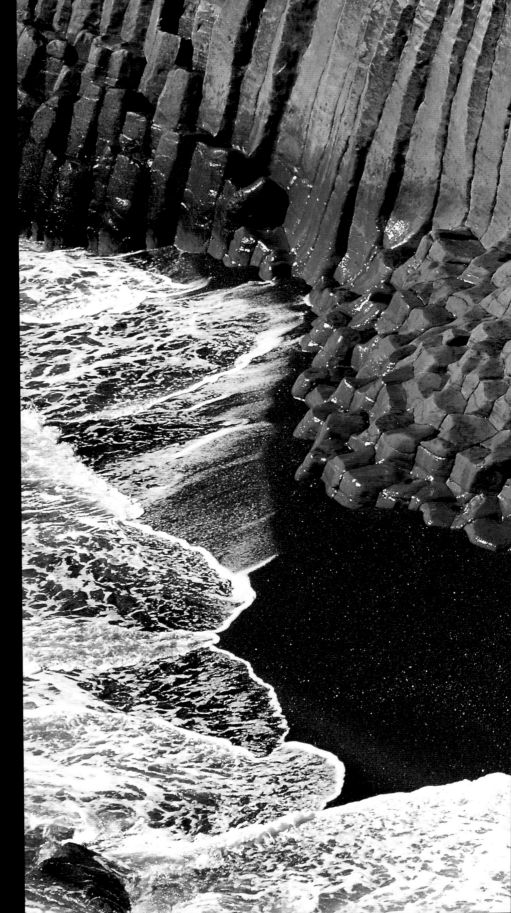

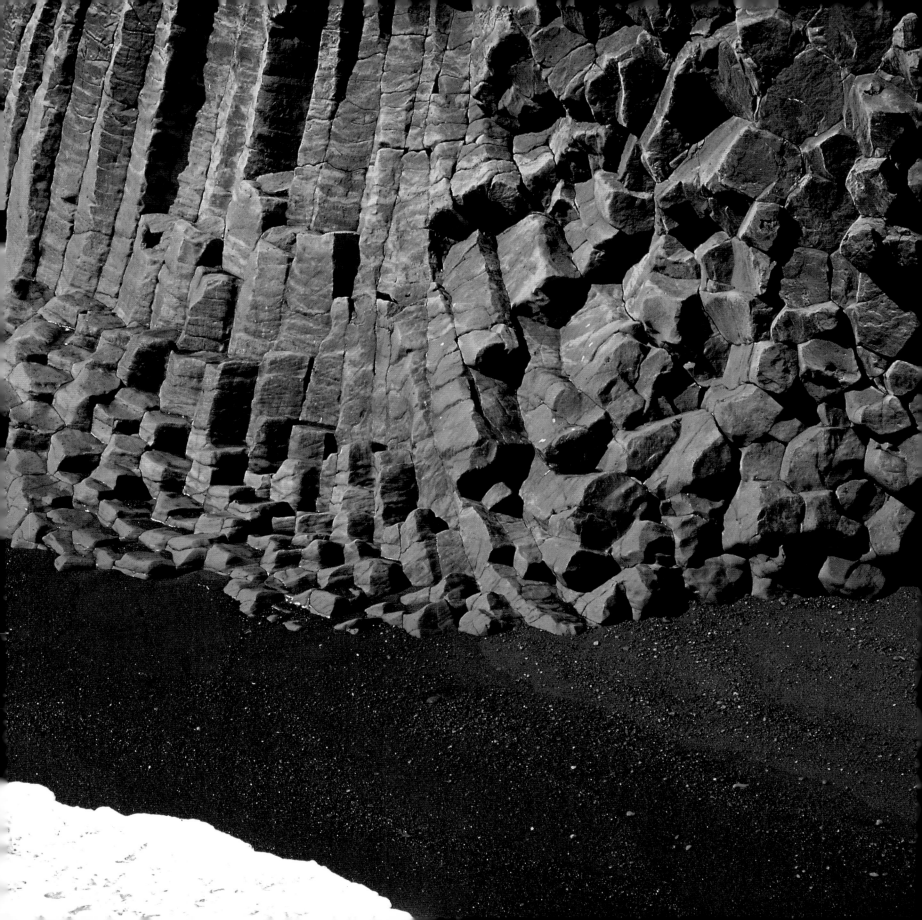

Staffan Widstrand
Sweden

ROCK WALL AND ICE, GREENLAND

This picture shows an island cliff in the largest national park in the world, the North-east Greenland National Park – some 900,000 square kilometres, virtually uninhabited and one of the least visited places on Earth. I took the shot from the expedition ship *Polar Star* in the Kong Oscar Fjord, which for most of the year is full of pack ice. This is polar desert – not only one of the coldest places in the northern hemisphere, but also one of the driest. At about 3am that August morning, this sheer rock wall, some 1,000 metres high, was lit by the low sun. The icebergs, the size of four-storey houses, show the scale.
Nikon F5 with 300mm f2.8 lens; 1/250 sec at f4; Fujichrome Velvia 50.

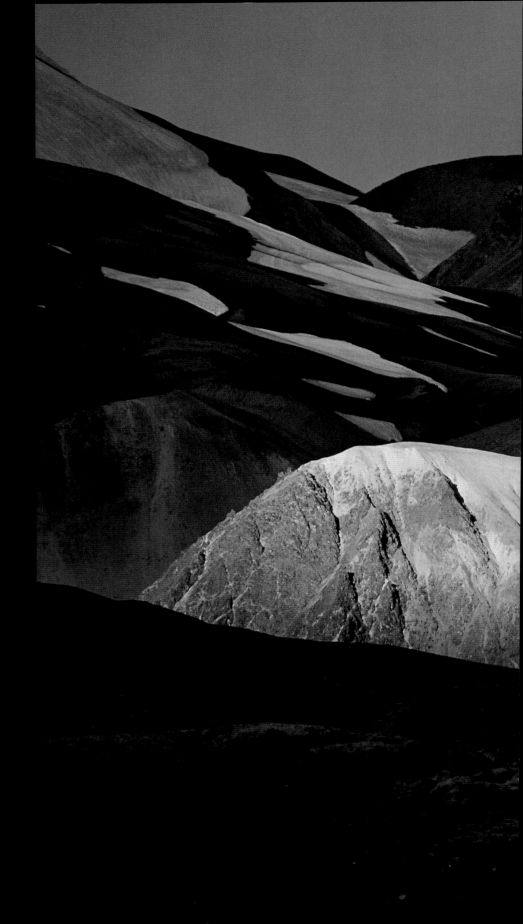

Reinhold Schrank
Austria

SPOT-LIT MOUNTAIN, ICELAND
The volcanic rhyolite mountains of Landmannalaugar, in the central highlands of Iceland, contain hints of red, orange and yellow, mixed with grey and black from volcanic lava. Locals call them the 'coloured mountains' because they change hue depending on the humidity and light. It was raining when I left my campsite and set off towards the nearest mountains. I set up my camera as soon as the rain stopped, and at that moment, the clouds parted and the sun beamed down like a spotlight, bathing the mountain in gold. A minute later, a blanket of cloud covered the sky once again.
Nikon F5 with Nikkor 80-400mm f1.4-f5.6 AF VR lens; 1 sec at f11; Fujichrome Velvia 50; tripod.

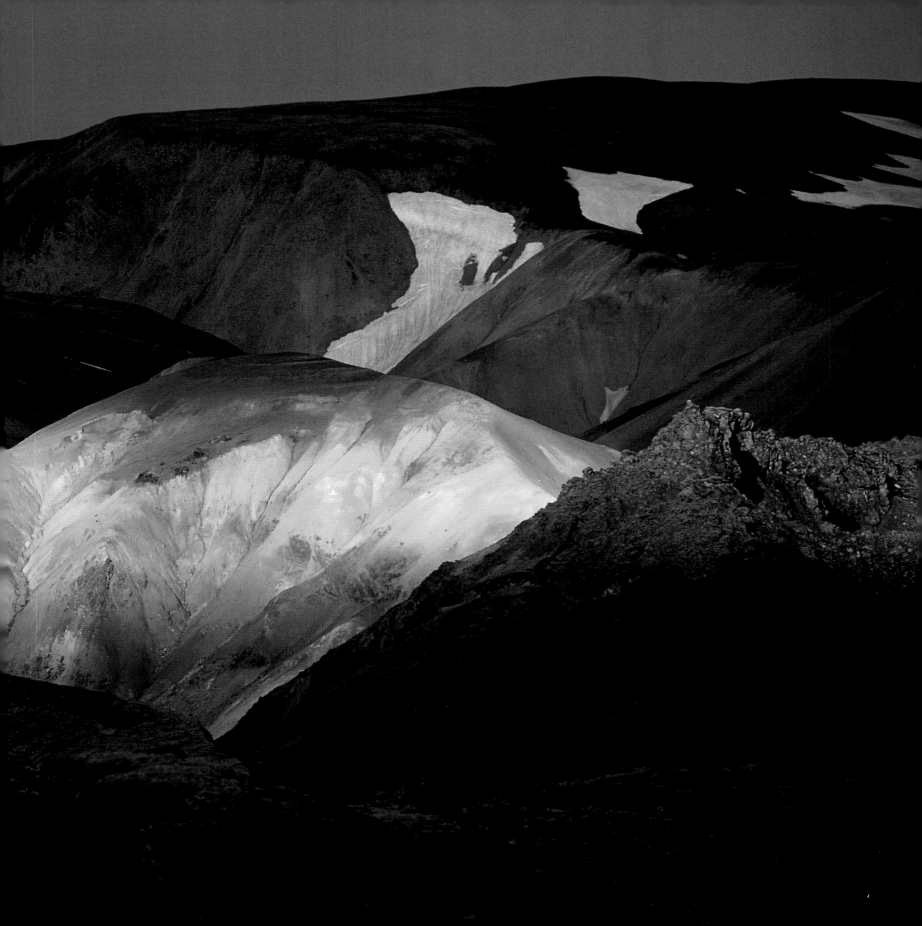

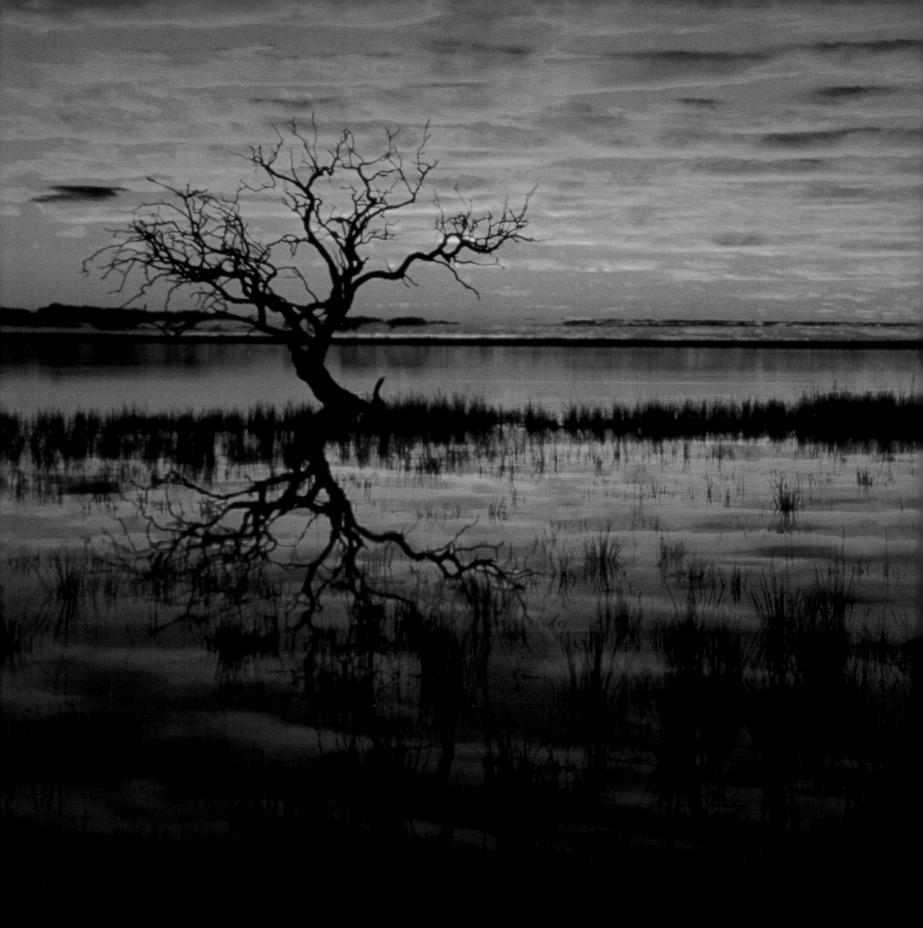

Didier D De Polla
UK

TREE AT SUNRISE

This desert wetland in central Australia, fed by a small underground stream, is the only source of water for thousands of kilometres. It's therefore a gathering point for birds and other animals. For humans, it's an incredibly difficult place to get to, approachable only over soft and treacherous sand.

I took the shot on a sandbar standing in water, just 30 seconds after sunrise. My aim was to capture a portrait that would conjure up the spirit of this desert oasis.

Nikon F100 with Nikon 17-35mm f2.8 lens; 15 sec at f16; Fujichrome Velvia 50; tripod.

123

The world in our hands

These pictures illustrate, whether symbolically or graphically, our dependence on and relationship with the natural world or our capability for damaging it.

HIGHLY COMMENDED

Trish Drury
USA

SLAUGHTERED COYOTES
This macabre exhibition of 100 or so coyotes was arrogantly displayed not far from Reelfoot National Wildlife Refuge near the Kentucky-Tennessee border. The state game warden informed me that coyotes are killed for fun rather than in response to harassment of livestock (of which there is little in this region). The offenders allegedly hunt the animals from four-wheelers at night, which is illegal, but they have to be caught in the act to be prosecuted. In an attempt to change attitudes, the warden is providing education programmes that emphasise the rodent-control role that coyotes play.
Nikon N90S with 24-120mm lens; Kodak Ektachrome E100VS; tripod.

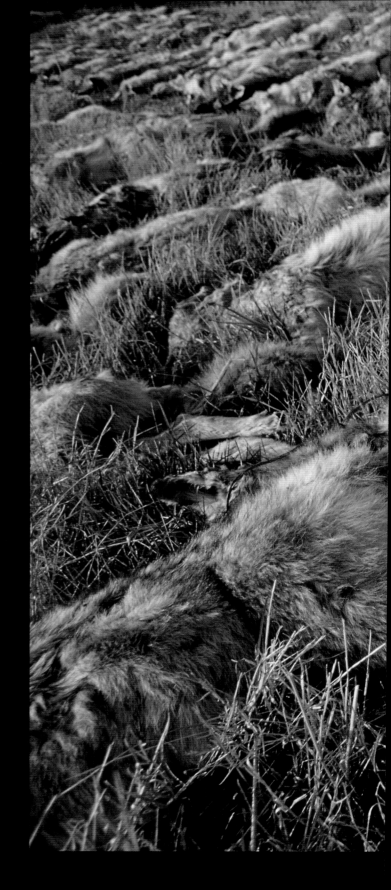

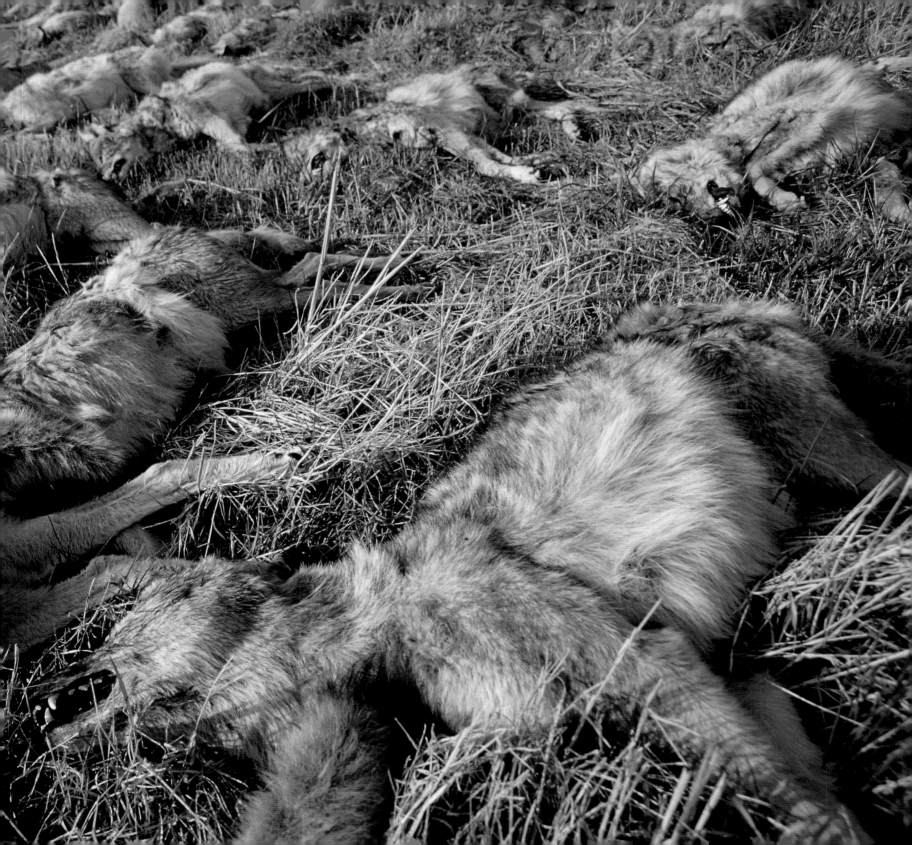

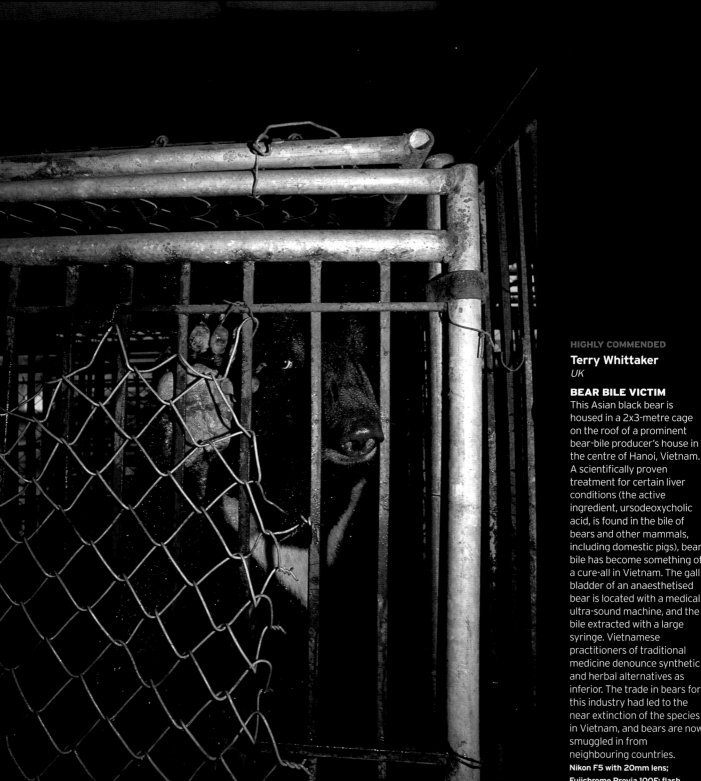

HIGHLY COMMENDED

Terry Whittaker
UK

BEAR BILE VICTIM
This Asian black bear is housed in a 2x3-metre cage on the roof of a prominent bear-bile producer's house in the centre of Hanoi, Vietnam. A scientifically proven treatment for certain liver conditions (the active ingredient, ursodeoxycholic acid, is found in the bile of bears and other mammals, including domestic pigs), bear bile has become something of a cure-all in Vietnam. The gall bladder of an anaesthetised bear is located with a medical ultra-sound machine, and the bile extracted with a large syringe. Vietnamese practitioners of traditional medicine denounce synthetic and herbal alternatives as inferior. The trade in bears for this industry had led to the near extinction of the species in Vietnam, and bears are now smuggled in from neighbouring countries.
Nikon F5 with 20mm lens; Fujichrome Provia 100F; flash.

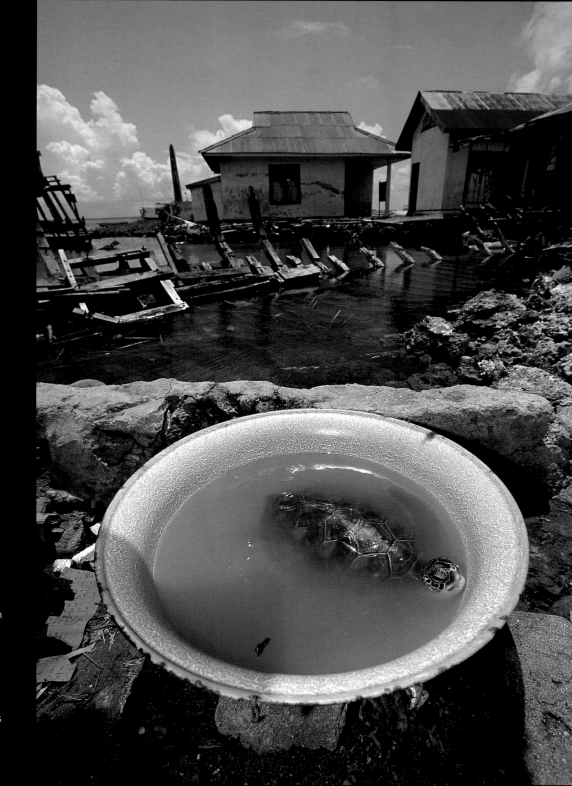

HIGHLY COMMENDED

Franco Banfi
Switzerland

GREEN TURTLE SOUP
We came across this young green turtle outside a local bar on the island of Tomia in the Tukangbesi Archipelago, in the Banda Sea, Indonesia. It was clearly suffering in such a small basin of dirty water in the full sun. My friend bought the turtle from the bar owner, explaining that she was keeping the animal in cruel conditions and that it would soon die (though the turtle may well have been on sale as food). We then released it back into the sea.
Nikon F100 with 17-35mm lens; 1/125 sec at f2.8; Fujichrome Velvia 50; strobe.

Award
Kobe Van Looveren

This award aims to encourage young and aspiring wildlife photographers to develop their skills and give them the opportunity to showcase their work. It was introduced in memory of Eric Hosking – Britain's most famous bird photographer – and goes to the best portfolio of six images taken by a photographer aged 26 or under.

Kobe has been in love with "the magnitude and beauty of nature" since a child, and at 15, his camera became his "best friend". He learnt photographic techniques from a friend's father, who encouraged him with positive criticism, and from reading every photographic book and magazine he could find. In 2000, he joined the Belgian nature photographers' association, the BVNF, which encouraged him to enter this competition, even offering to pay for the postage. The result was that he won the title Young Wildlife Photographer of the Year 2000. He subsequently obtained a degree in landscape architecture while continuing to develop his own style of photography. He is now training to become a multimedia producer, but wildlife photography remains his passion.

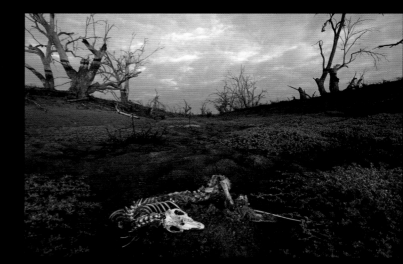

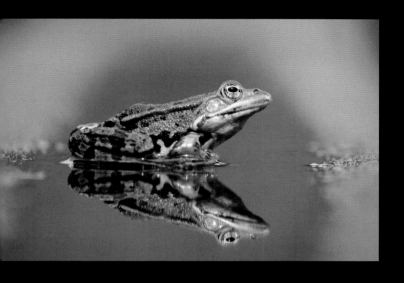

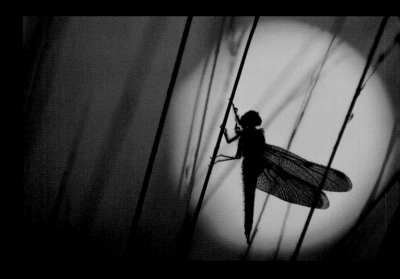

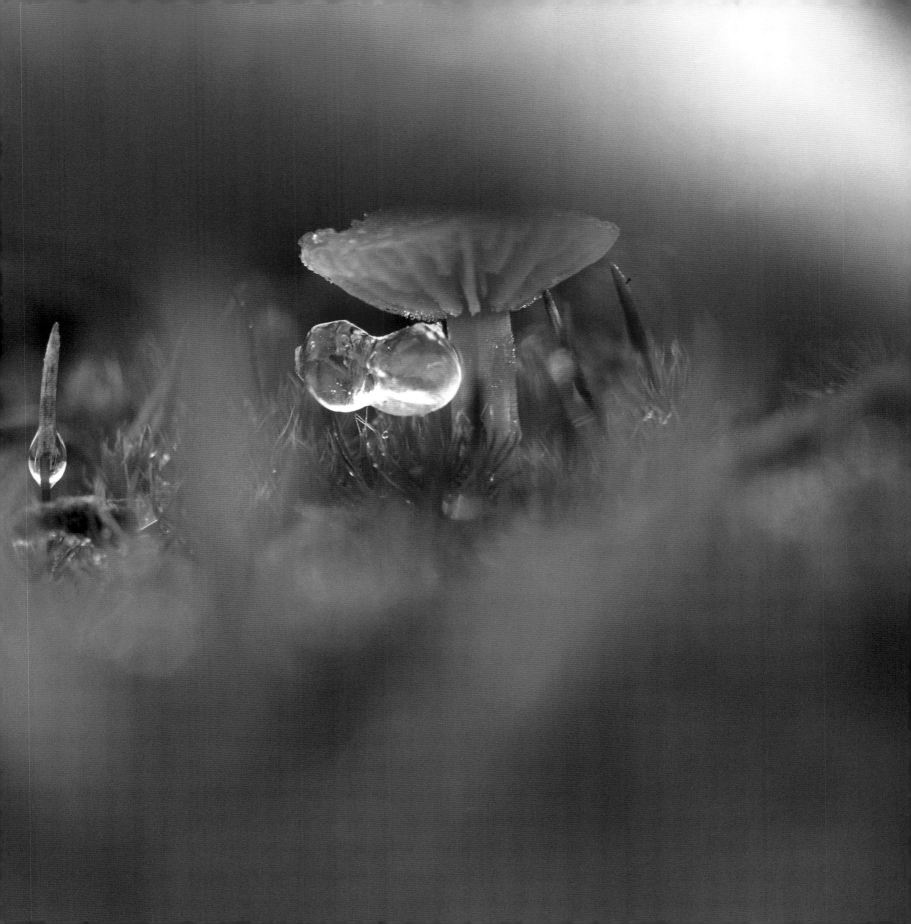

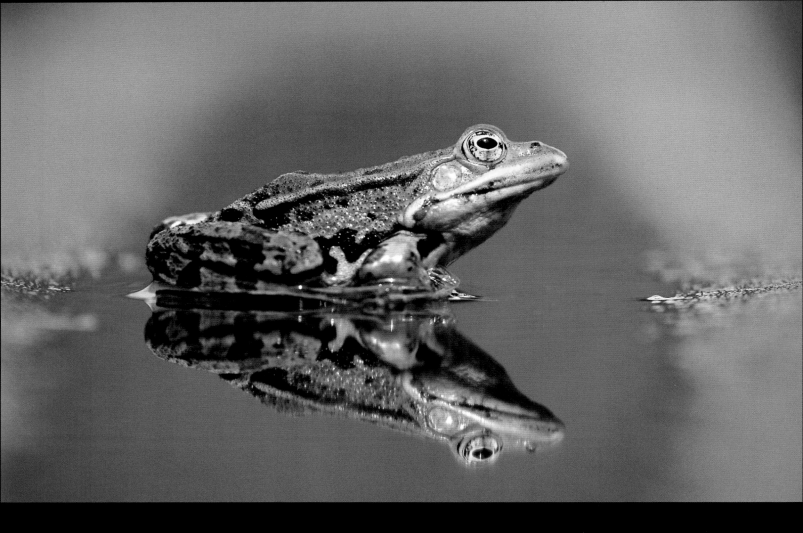

GREEN FROG

Our pond is full of green frogs. They spend most of their time in the water but emerge to catch insects. After a summer shower, this one sat on the edge. Keeping in mind that it could jump away any minute, I quickly set to work, choosing a long lens. The soft light of an overcast sky meant there were no hard shadows – perfect conditions for taking a portrait of a damp amphibian against water.

Nikon F90 with 400mm lens; 1/250 at f5.6; Fujichrome Sensia 100; tripod.

ICE SCULPTURES
These fragile ice drops lasted just a short time but long enough to take a picture. The ice had formed around grass stems at the surface of the lake and, as the sun came up and the water level dropped, the remaining fragments of ice were left high and dry.
Nikon F90 with 105mm lens; 1/30 sec at f11; Fujichrome 100; tripod.

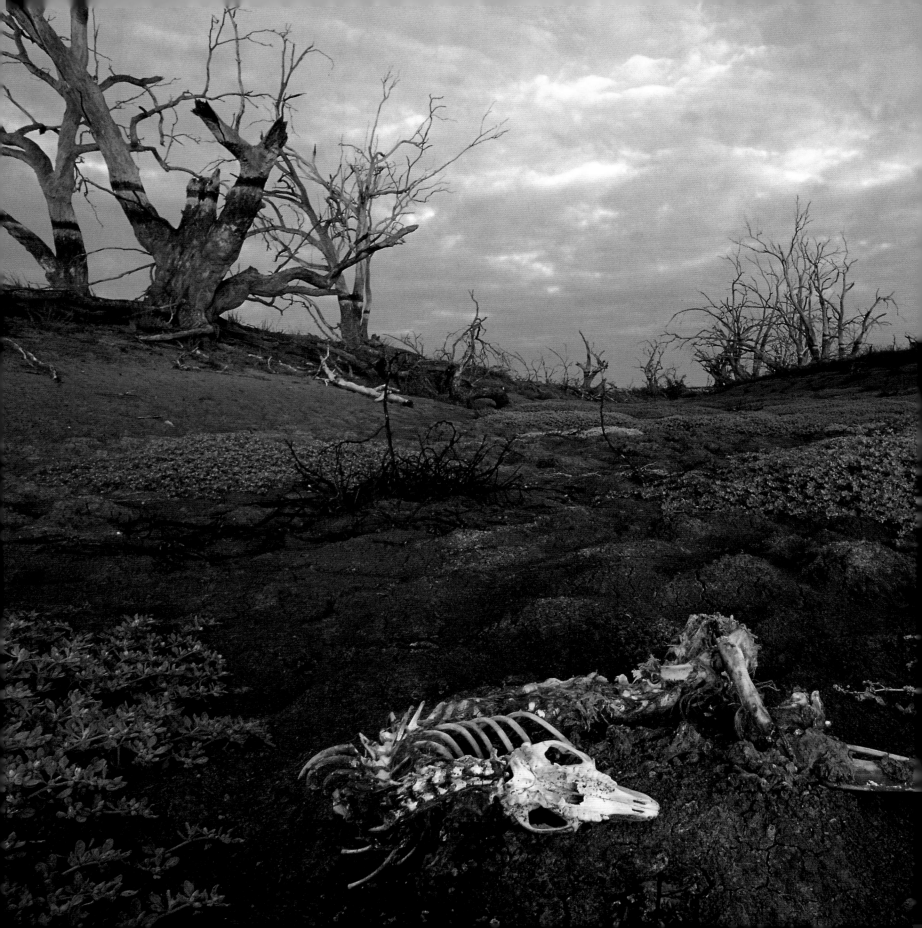

EMU SKELETON

The Menindee Lakes in Kinchega National Park, New South Wales, Australia, are seven times larger in water area than Sydney Harbour and are a haven for wildlife. But when I visited in May 2003, an extreme drought was in progress, and they were almost all dry. Many animals, desperate for water, had become stuck in the mud and died a lingering death, and on some parts of this riverbed, there was an emu skeleton almost every 20 metres.

Nikon F90 with 20mm lens; 1/30 sec at f22; Fujichrome Velvia 50.

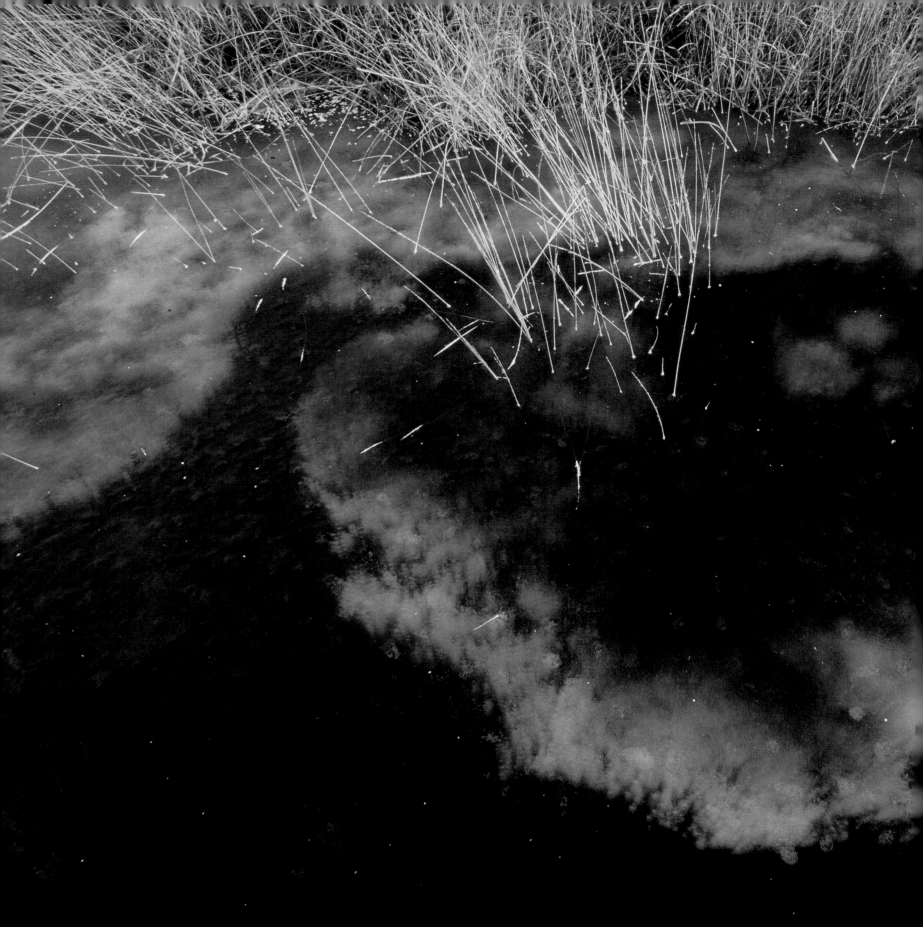

WINTER POND IN MORNING LIGHT
Early one bitterly cold winter morning, I set out to take photographs, and at first, found nothing obvious to shoot. But first impressions are never good enough for a photographer, and so I went to a frozen pond and waited for the sun to rise, knowing that, if the light is good, there is always something to photograph. Then I spotted the ice bubbles. The frosted grass provided the backdrop, and the sun highlighted it with an apricot glow – a perfect combination.
Nikon F90 with 20mm lens; 1/60 sec at f22; Fujichrome Sensia 100; tripod.

**FOUR-SPOTTED CHASER
WARMING UP**
Early one summer morning, I
discovered this four-spotted
chaser catching the sun's first
rays. Using its legs, it was
rubbing dew from its eyes.
Dragonflies depend on the
sun's warmth to regulate their
temperature. So when it's
cold, they tend to roost in
sheltered places that will
catch the sun in the morning.
My macro lens enabled me to
get close enough – about
80cm away – to capture the
sunrise scene without
disturbing the chaser.
**Nikon F90 with 105mm lens;
1/125 sec at f4; Fujichrome Sensia
100; tripod.**

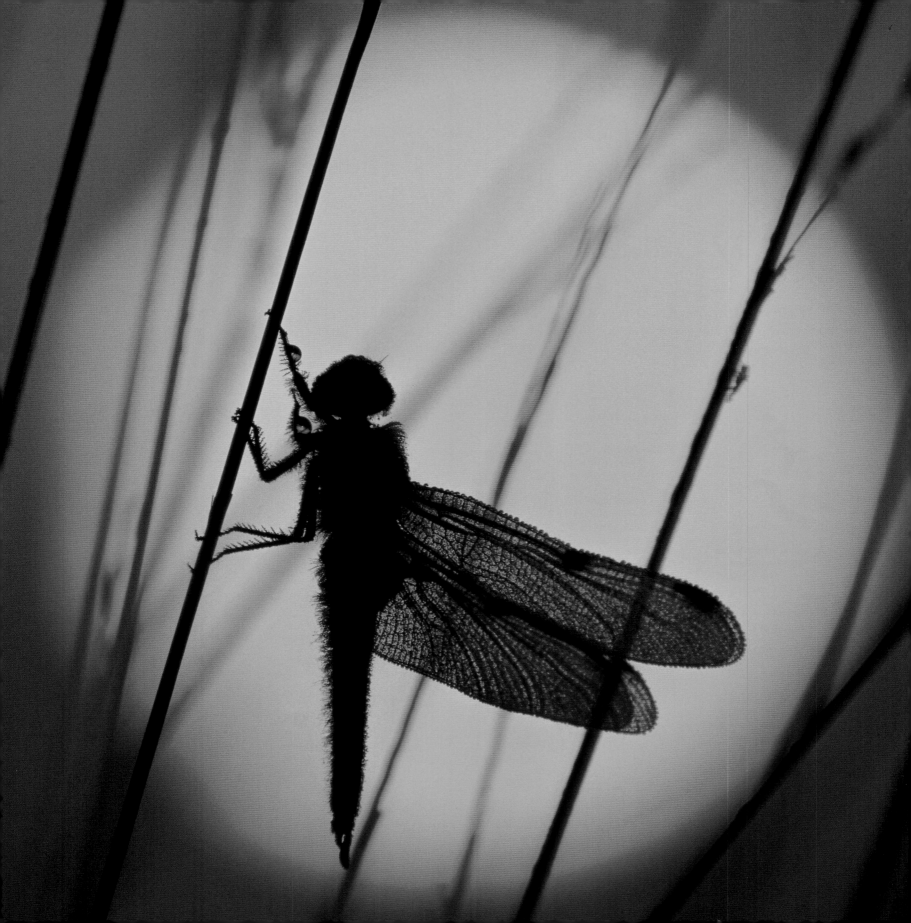

Young Wildlife Photographer of the Year

Gabby Salazar

This award is given to the photographer whose single image is judged to be the most striking and memorable of all the pictures entered in the categories for young photographers aged 17 or under.

Gabby went on her first photo trip at 12 and was instantly hooked. She and her younger sister and father now go on regular trips, as far afield as Russia, learning from each other. But she prefers to take pictures close to home in North Carolina. She had her first picture published when just 14, on the cover of *Our State* magazine. A turning point was a scholarship to attend the summit of the North American Nature Photography Association, after which she determined to dedicate her life "to preserving the natural world." Now 17, she has already won several photographic awards and is pursuing a degree in biochemistry.

 WINNER (15-17 YEARS)

Gabby Salazar
USA

GREEN ANOLE
I was scouting for insects on the flowers in the Valley Nature Center in Weslaco, south Texas, when a flash of pink caught my attention. It was a male green anole displaying its dewlap, a large pink fan of skin on its neck, as a territorial 'flag'. But he stopped as I approached. As he was no more than 12 centimetres long, I needed to get as close as possible to take a photograph, and so I edged very slowly forward, trying to avoid the sharp spines of a prickly pear cactus, until I could focus and then waited until he moved forward into the early morning light, providing a pose for a portrait that summed up for me the essence of lizard.
Nikon F5 with Nikon 70-180mm lens; f4.5-5.6; Fujichrome Provia 100.

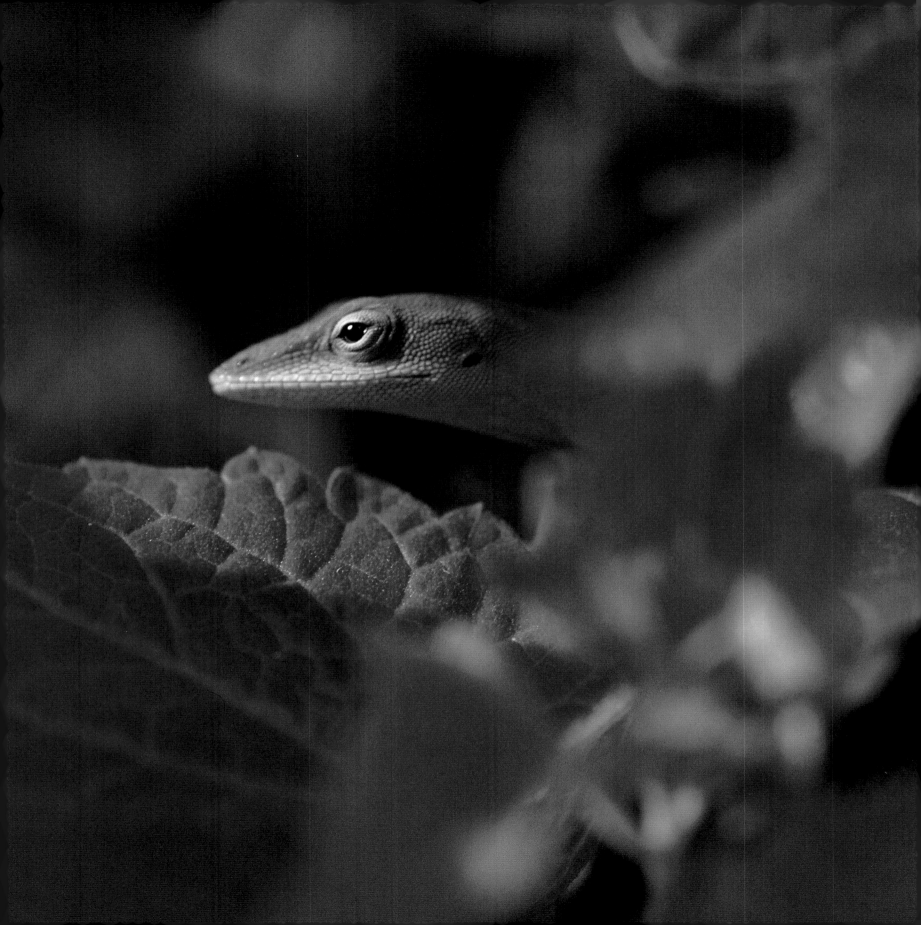

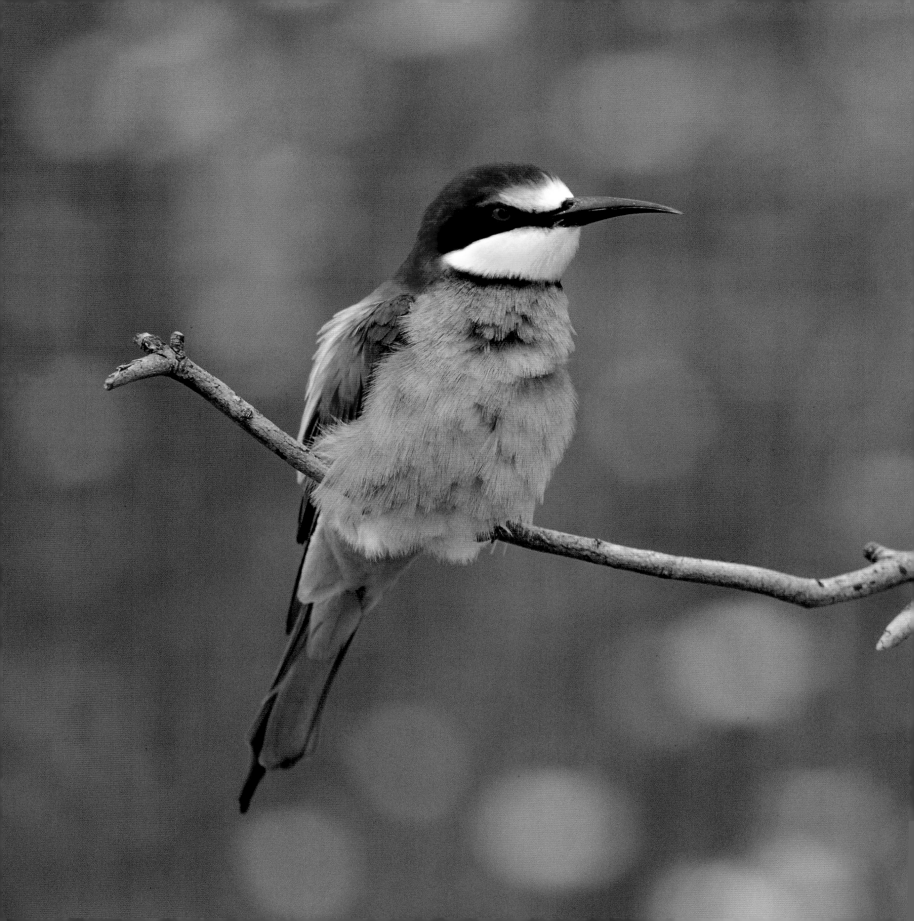

 RUNNER UP

Christoph Müller
Germany

EUROPEAN BEE-EATER

My family spent the Easter
holidays in Extremadura in
mid-western Spain. After
photographing bee-eaters at
two different spots with only
moderate success, we found
another spot with lots of
colourful flowers close
to a bee-eater colony in a
sandbank. I stuck a stick into
the ground, hoping it would
be a tempting perch, because
the purple and the white
flowers were such a perfect
backdrop. I had to wait for an
hour for a bee-eater to try out
the perch – and it was
another two hours before
the individual in the photo
arrived and posed for me.
**Canon EOS 100 with 500mm f4
lens; 1/250 sec at f5.6; Kodak
Ektachrome 100; tripod.**

143

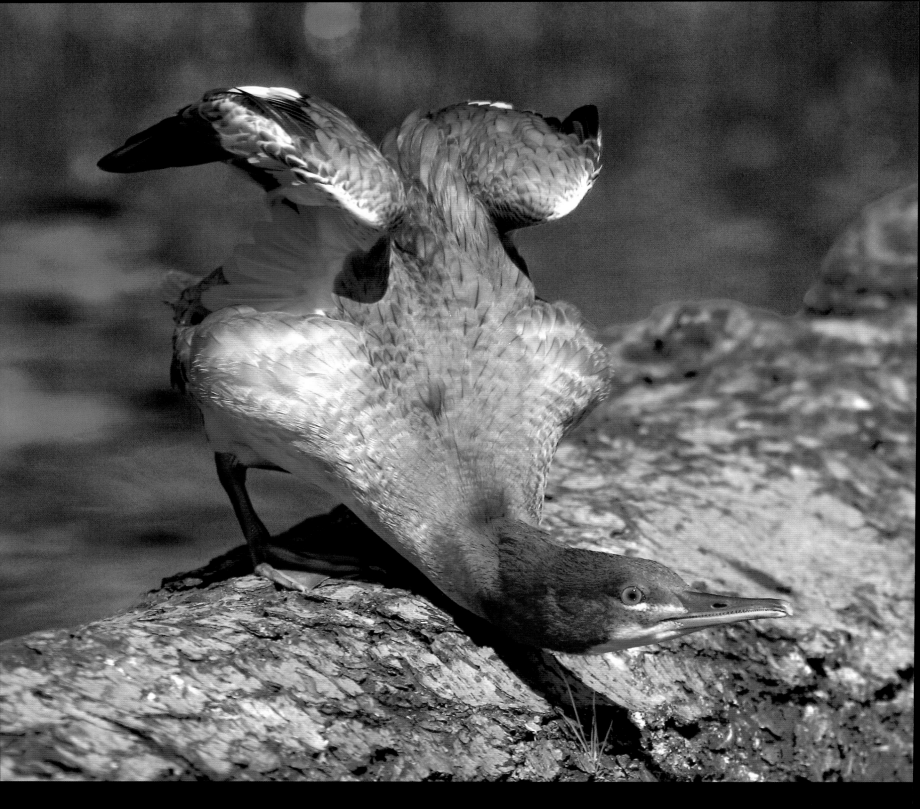

11-14 years

 WINNER

Fergus Gill
UK

**NORTHERN LIGHTS,
SCOTLAND**

In November, my dad spent
several nights watching the
aurora borealis – the northern
lights – until after midnight.
When a week later they began
again a little earlier in the
evening, I thought I would join
him. We went to Gallowhill,
not far from my home in
Perthshire. It was fantastic.
The moving colours kept
reappearing and disappearing
as the solar wind interacted
with the Earth's geomagnetic
field. It was freezing cold, but
I stayed out for nearly three
hours and managed to take
four or five good
photographs. This one was
the most dramatic.
**Nikon FA with 24mm lens;
two or three minutes' exposure;
Fujichrome Velvia 100F; tripod and
cable release.**

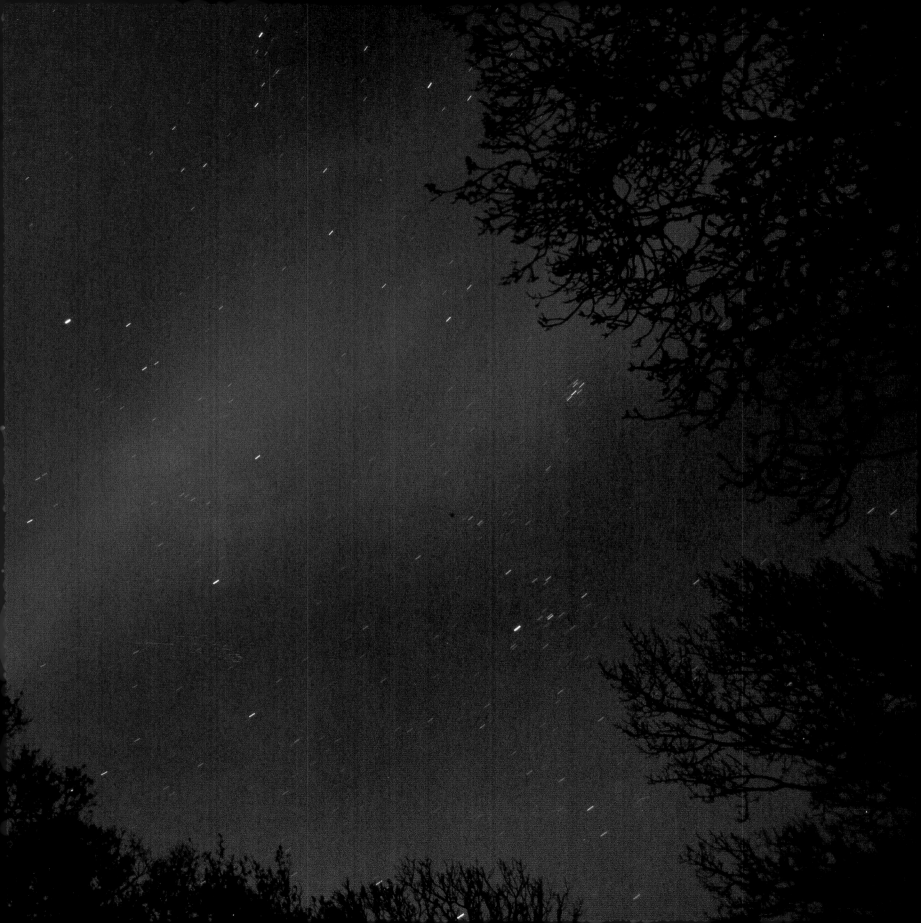

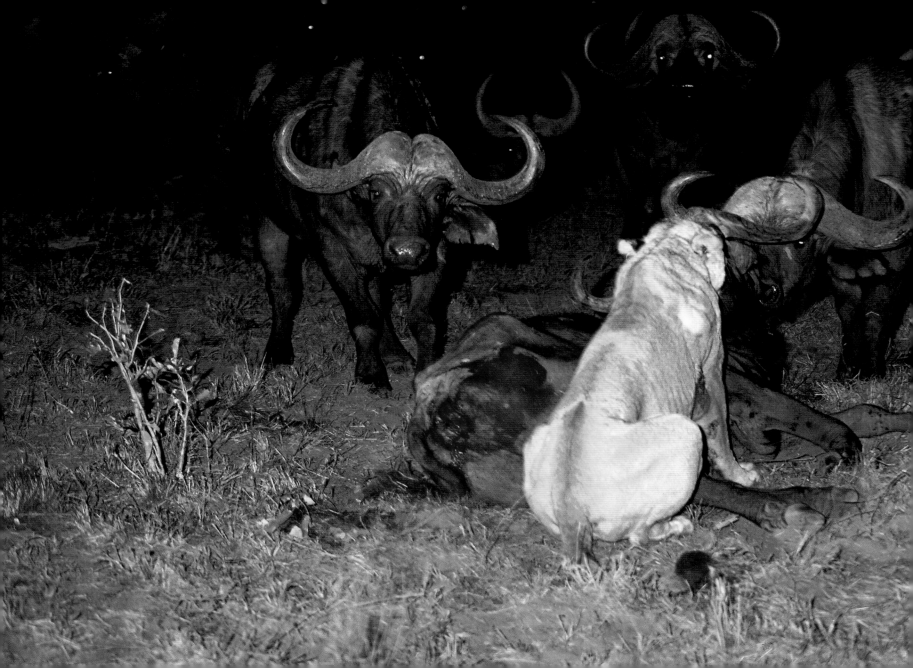

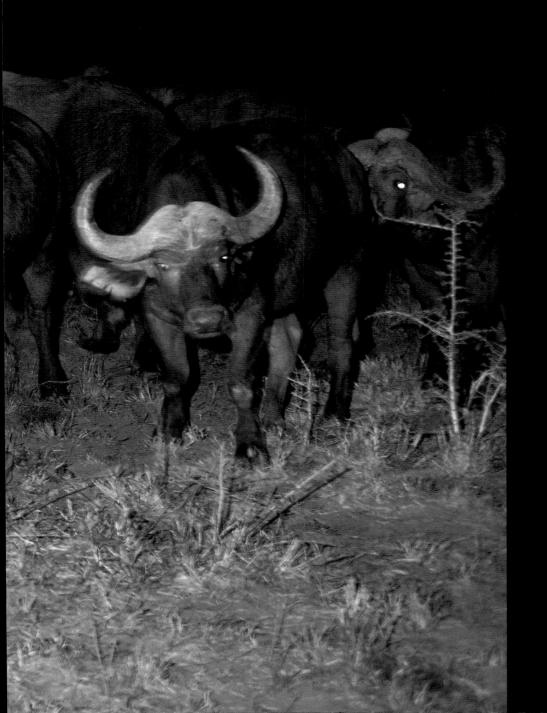

 RUNNER-UP

Olivia McMurray
South Africa

LIONESS AT BAY

On a cool summer's night in South Africa's Mala Mala Game Reserve, we followed a pride of 13 lions as they stalked a buffalo herd. The lions selected an old cow who was lying down. When the attack began, the other buffalo came to her rescue. This lioness was the only one of her pride to stand her ground against the approaching would-be rescuers. After a while her courage waned and she too fled to join the rest of her pride.

Canon EOS 1 with 70-200mm lens; 1/30sec at f2.8; Fujichrome Provia 100; 2.5kw Tungsten lights.

149

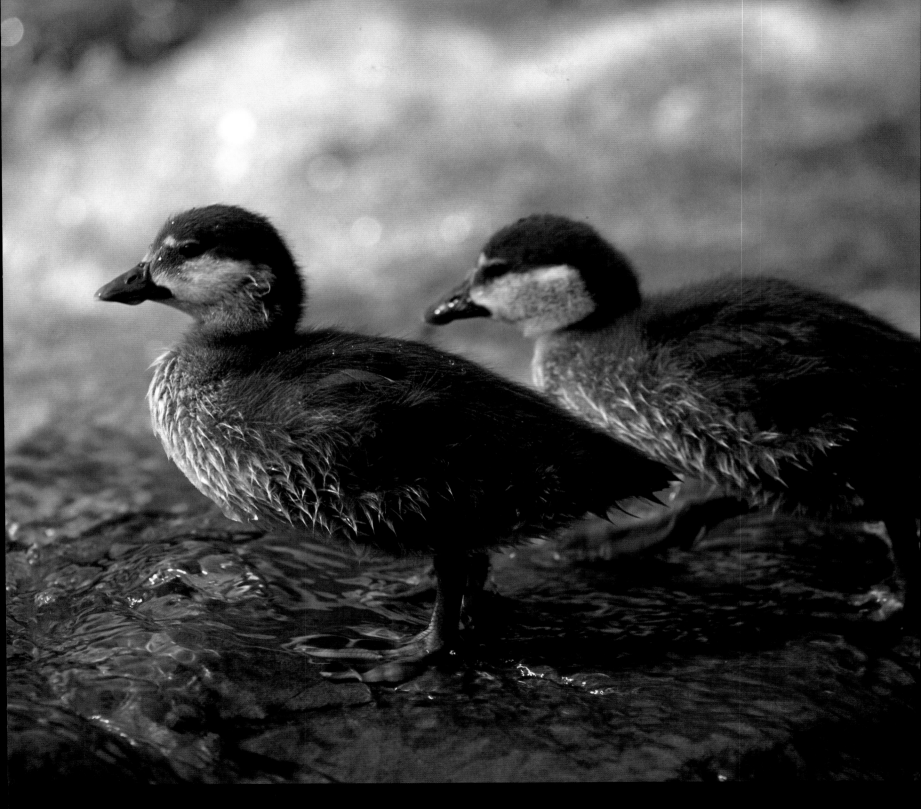

O years
nd under

 WINNER

ille Ritonen
nland

URIOUS JAY
ist December, my father
ok me with him to a hide
oout 30 kilometres from our
ouse. We spent the next two
ays taking photographs of
rds, including woodpeckers
nd jays. The first day was
ither overcast, but on the
econd day, the sun began to
nine. In the afternoon, I saw
his jay peeking out from
ehind a pine tree, lit by
eautiful sunlight. I slowly
irned my camera towards
ne jay, hoping all the time
hat it wouldn't suddenly fly
way. It didn't.

**ikon F55 with Sigma 400mm f5.6
PO macro lens; 1/60 sec at f5.6;
ijichrome 100; hide; tripod.**

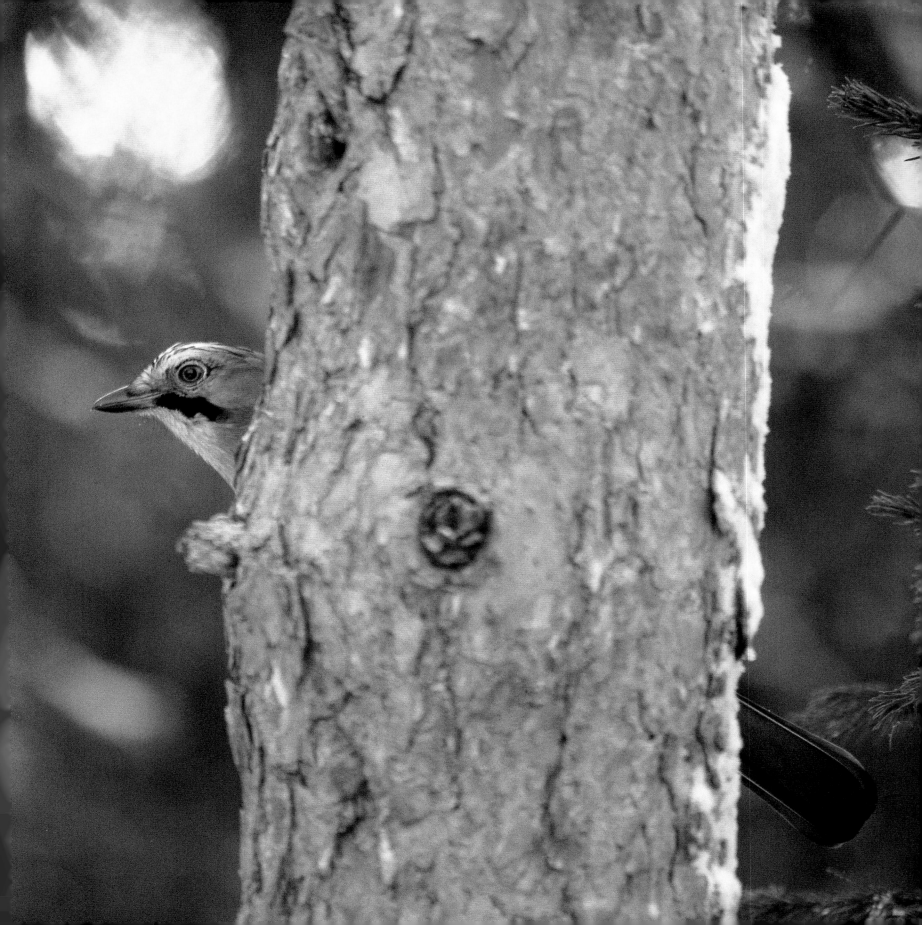

Young Wildlife Photographers
of the Year –
10 years and under

 RUNNER-UP

Nicholas Cancalosi Dean
USA

TIMBER RATTLESNAKES BASKING

Papa and I spent several days watching and photographing these rattlesnakes in a forest in Pennsylvania. The females gather to bask in a warm place, to help their babies grow inside their bodies. They give birth to live young in late summer. Sometimes, people kill or collect rattlesnakes. So those who know where the snakes' denning and birthing sites are keep it a secret. I know the snakes are venomous, but they're not aggressive. As long as you are very careful and keep your distance, you are safe. But just in case, I wore hockey pads on my legs, and borrowed Papa's zoom lens.
Canon EOS 1DS with Canon 100-400mm IS lens; tripod, flash.

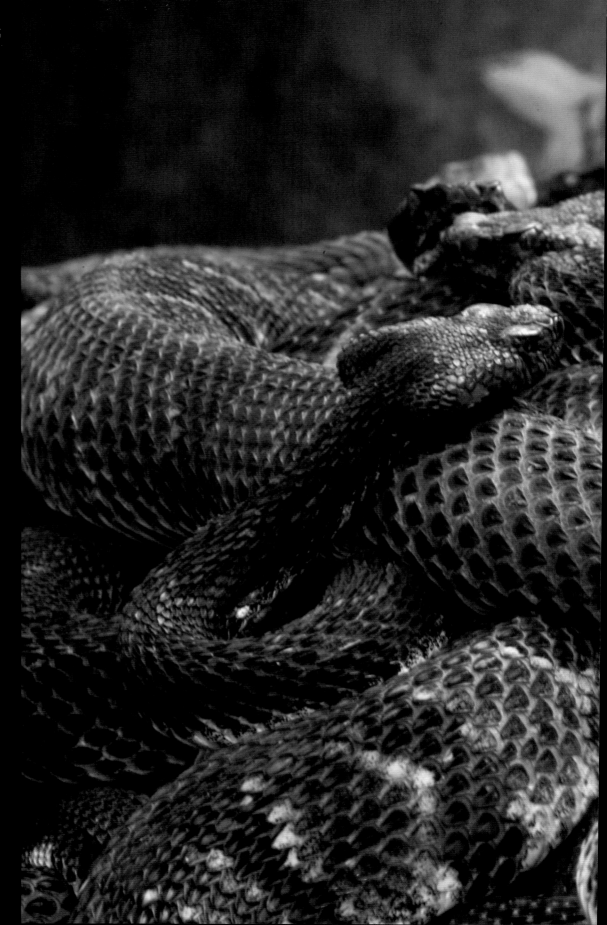

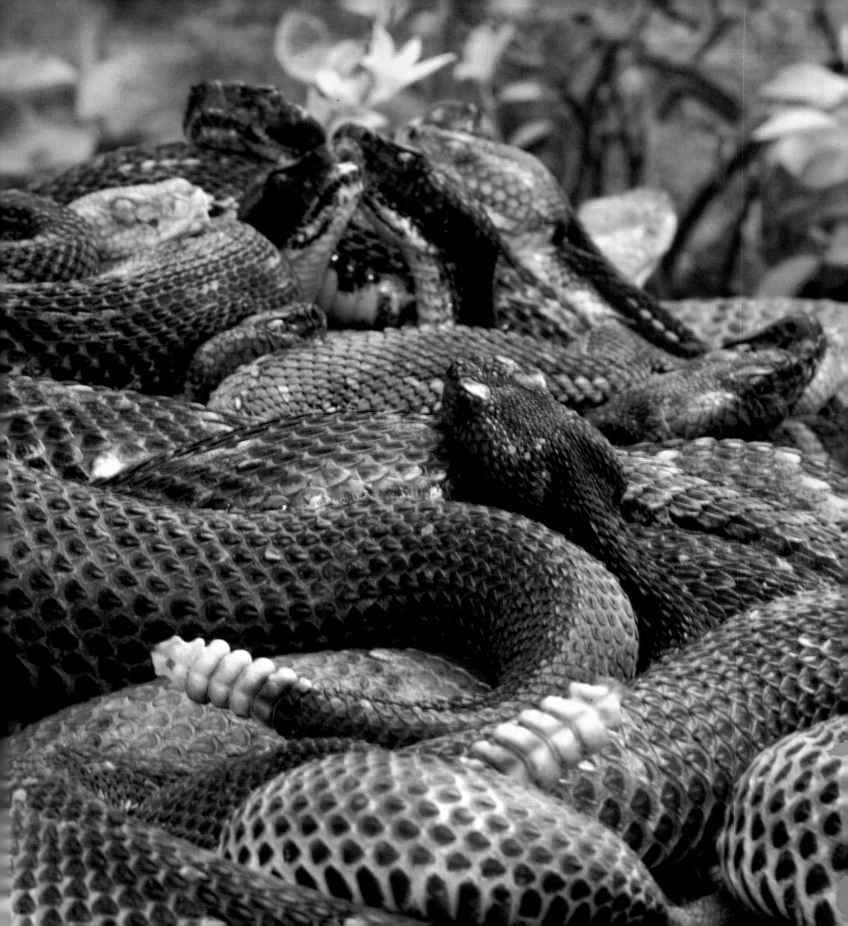

Index of photographers

The numbers before the photographers' names indicate the pages on which their work can be found. All contact numbers are listed with international dialling codes from the UK – these should be replaced when dialling from other countries.

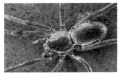

88, 110 Theo Allofs
PO Box 31793
Whitehorse YT
Y1A 6L3
CANADA
Tel: (001) 867 667 6000
Fax: (001) 867 667 6002
Email: info@theoallofs.com
www.theoallofs.com

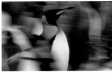

72 Ingo Arndt
Mittelgasse 15
64546 Moerfelden
GERMANY
Tel: (0049) 6105 1737
Fax: (0049) 6105 26709
Email: i.arndt-photo@t-online.de
www.arndt-photo.com

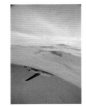

12 Pete Atkinson
Windy Ridge, Hyams Lane
Holbrook, Ipswich
Suffolk IP9 2QF
UK
Tel: 01473 328349
Email: yachtvigia@hotmail.com
www.peteatkinson.net

AGENTS
Getty Images
101 Bayham Street
London NW1 0AG UK
Tel: 020 7267 8988
Fax: 020 7544 3436
Email: sales@gettyimages.com
www.gettyimages.com

NHPA Limited
57 High Street
Ardingly
West Sussex RH17 6TB
UK
Tel: 01444 892514
Fax: 01444 892168
Email: info@nhpa.co.uk
www.nhpa.co.uk

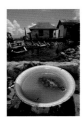

127 Franco Banfi
Via Camana
6965 Cadro
SWITZERLAND
Tel: (0041) 091 9435694
Fax: (0041) 091 9435694
Email: franco@banfi.ch
www.banfi.ch

93 Danny Beath
42 Oaklands
Gains Park
Shrewsbury
Shropshire SY3 5BG
UK
Tel: 01743 343563
Email: dannybeath@hotmail.com
www.smilingleafimages.co.uk

62 Tobias Bernhard
PO Box 1427
Whangarei
NEW ZEALAND
Tel: (0064) 2 1038 3727
Email: wildimages@hotmail.com
www.tobiasbernhard.com

Agents
OSF Picture Library
Ground Floor, Network House
Station Yard
Thame
Oxfordshire OX9 3UH
UK
Tel: 01844 262370
Fax: 01844 262380
Email: photo.library@osf.uk.com
www.osf.uk.com

Getty Images
101 Bayham Street
London NW1 0AG
UK
Tel: 020 7267 8988
Fax: 020 7544 3436
Email: sales@gettyimages.com
www.gettyimages.com

ZEFA Visual Media UK Ltd
Threeways House
40-44 Clipstone Street
London W1W 5DW
UK
Tel: 020 7079 0540
Fax: 020 7079 0541
Email: info@zefa.co.uk
www.zefa.co.uk

89 Melker Blomberg
Rytterne 7
Svånö
725 92 Vasteras
SWEDEN
Tel: (0046) 70 215 67 00
Email:
melker.blomberg@swipnet.se

103 Andrea Bonetti
PO Box 4656
24001 Pylos
GREECE
Tel: (0030) 6972 679645
Tel/Fax: (0030) 27230 41634
Email: r_r_skywalker@hotmail.com
www.greeknature.com

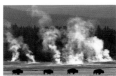

34 Peter Cairns
Ballintean
Glenfeshie
Kingussie PH21 1NX
SCOTLAND
Tel: 01540 651352
Email: info@northshots.com

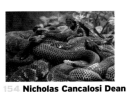

154 Nicholas Cancalosi Dean
c/o 1532 Maplewood Drive
Slidell
LA 70458
USA
Tel: (001) 607 262 0990
Email: cancalosi@earthlink.net

86 Bernard Castelein
Verhoevenlei 100
2930 Brasschaat
BELGIUM
Tel: (0032) 3 653 08 82
Fax: (0032) 3 653 08 82
Email: bernard.castelein@vt4.net

Agent
Nature Picture Library
BBC Broadcasting House
Whiteladies Road
Bristol BS8 2LR
UK
Tel: 0117 974 6720
Fax: 0117 923 8166
Email: info@naturepl.com
www.naturepl.com

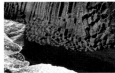

116 Régis Cavignaux
29 rue Saint Nicolas
54280 Champenoux
FRANCE
Tel: (0033) 83 31 69 45
Fax: (0033) 83 33 19 28
Email: rcavignaux@wanadoo.fr

Agent
BIOS
31 rue Chanzy
75012 Paris
FRANCE
Tel: (0033) 143 56 63 63
Fax: (0033) 143 56 65 17
Email: bios@biosphoto.com
www.biosphoto.com

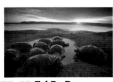

78, 98 Tui De Roy
The Roving Tortoise
Patons Rock Beach
Takaka 161
Golden Bay
NEW ZEALAND
Tel: (0064) 3 525 8370
Fax: (0064) 3 525 8370
Email: photos@rovingtortoise.co.nz

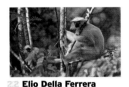

22 Elio Della Ferrera
Via Signorie, 3
23030 Chiuro (SO)
ITALY
Tel: (0039) 0342 213254
Fax: (0039) 0342 213254
Email: eliodellaferrera@iname.com

Agent
Nature Picture Library
BBC Broadcasting House
Whiteladies Road
Bristol BS8 2LR
UK
Tel: 0117 974 6720
Fax: 0117 923 8166
Email: info@naturepl.com
www.naturepl.com

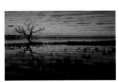

122 Didier D De Polla
15 Penn Road
Fenny Stratford
Milton Keynes MK2 2AU
UK
Tel: 07940 376727
Fax: 01908 632666
Email: didflid@hotmail.com
www.travellingwithoutmoving.com

Agent
Photopia
8 Bessemer
Milton Keynes
MK15 5JW
Tel: 07958 459704

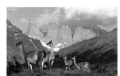

38 Cornelia & Ramon Dörr
Eisenstuckstrasse 5a
09114 Chemnitz
GERMANY
Tel: (0049) 371 3350591
Fax: (0049) 371 3349675
Email: doerr-photo@t-online.de
www.doerr-naturbilder.de

124 Trish Drury
1720 Wood Creek Circle
Athens
TN 37303
USA
Tel: (001) 423 745 3622
Fax: (001) 423 745 1226
Email: druryphoto@earthlink.net

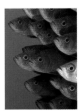

68 Barbara Karen Evans
56 Glendale Road
Bellair
Kwa-Zulu Natal
4094
SOUTH AFRICA
Tel: (0027) 83 3210 115
Fax: (0027) 31 4656 353
Email: barbara@planetblue.co.za
www.planetblue.co.za

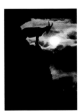

100 Luca Fantoni
Via Monviso 11/A
20050 Camparada (MI)
ITALY
Tel: (0039) 606 9943
Email: fantoniluca4@virgilio.it

100 Danilo Porta
Via Giuseppe Verdi 10
20050 Lesmo (MI)
ITALY
Email: danilo.porta@db.com

66 Angel M Fitor
Av. Cardenal Fco. Alvarez 5. 8°K
03005 Alicante
SPAIN
Tel: (0034) 965 181 400
Email: seaframes@seaframes.com
www.seaframes.com

Agents
Seaframes, a sea of pictures
(Contact details above)

OSF Picture Library
Ground Floor, Network House
Station Yard
Thame
Oxfordshire OX9 3UH
UK
Tel: 01844 262370
Fax: 01844 262380
Email: photo.library@osf.uk.com
www.osf.uk.com

26 Howie Garber
3926 Feramorz Drive
Salt Lake City
UT 84124
USA
Tel: (001) 801 272 2134
Fax: (001) 801 277 0687
Email:
howie@wanderlustimages.com
www.wanderlustimages.com

146 Fergus Gill
Yewtree Cottage
7 Dunsinnan Road
Wolfhill
Perthshire PH2 6TL
SCOTLAND
Tel: 01821 650455
Email: fergus@wolfhill.free-online.co.uk

114 Irene Greenberg
PO Box 10047
Jackson
WY 83002
USA
Tel: (001) 307 733 8432

144 Jerzy Grzesiak
ul. Czajkowskiego 8 m. 50
92 511 Lodz
POLAND
Tel: (0048) 608 108 170
Fax: (0048) 42 673 13 93
Email: ajrgrz@ld.onet.pl
www.grzesiak.kei.pl/jurek
www.jurek.grzesiak.prv.pl

80 Tore Hagman
Box 12
447 21 Vårgårda
SWEDEN
Tel: (0046) 322 623236
Fax: (0046) 322 623236
Email: images@tiscali.se
Email: info@torehagman.se

20 A L Harrington
17 Milton Street
Banbury
Oxon OX16 9PL
UK
Tel: 01295 277452
Email:
harry@harringtonphotography.com
www.harringtonphotography.com

54 Gerald Hinde
12 Rose Hollow
Bella Street
Lakefield
Benoni 1500
SOUTH AFRICA
Tel: (0027) 11 894 5262
Fax: (0027) 11 894 5262
Email: hinde@netactive.co.za

58 Charles Hood
69 Hartfield Road
Wimbledon
London SW19 3TJ
UK
Tel: 07712 622440
Email: charleshood@mac.com
www.charleshood.com

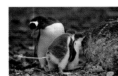

44 Lars-Olof Johansson
Flottiljvägen 8
183 50 Täby
SWEDEN
Tel: (0046) 8 756 10 72
Email: lars-olof.johansson@lo-naturephoto.se
www.lo-naturephoto.se

60 Mark Jones
The Roving Tortoise
Patons Rock Beach
Takaka 161
Golden Bay
NEW ZEALAND
Tel: (0064) 3 525 8370
Fax: (0064) 3 525 8370
Email: photos@rovingtortoise.co.nz

90 Balázs Kármán
Kodály u 47
6792 Zsombó
HUNGARY
Tel: (0036) 62 432 027
Fax: (0036) 62 432 027
Email: karman@fotoklikk.hu
www.naturephoto.hu

52, 101 Steven J Kazlowski
6201 - 15th Avenue NW, #501
Seattle
WA 98107
USA
Tel: (001) 206 706 7632
Email: steven@lefteyepro.com
www.lefteyepro.com

114 Gábor Kiss
9 Cseppko utca
1025 Budapest
HUNGARY
Tel: (0036) 30 977 9305
Email: kissgaborfoto@yahoo.com

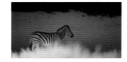

96 Peter Lilja
Medlevâgen 138
931 98 Skellefteå
SWEDEN
Tel: (0046) 910 770029
Email: peter@peterlilja.com
www.peterlilja.com

Agent
Getty Images
101 Bayham Street
London NW1 0AG
UK
Tel: 020 7267 8988
Fax: 020 7544 3436
Email: sales@gettyimages.com
www.gettyimages.com

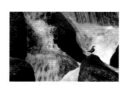

94 Alf Linderheim
Box 38
814 25 Älvkarleby
SWEDEN
Tel: (0046) 70 6161948
Email: linderheim@ebox.tninet.se

Agent
Naturfotografernas Bildbyrå AB
Box 2173
103 14 Stockholm
SWEDEN
Tel: (0046) 8 10 65 35
Email: info@naturfotograferna-bildbyra.se
www.naturfotograferna-bildbyra.se

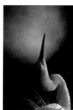

76 David Macri
517 Anastasia Blvd.
St. Augustine
FL 32080
USA
Tel: (001) 904 461 0624
Fax: (001) 904 471 0017
Email: macri@bellsouth.net
www.davidmacri.com

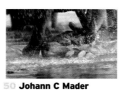

50 Johann C Mader
PO Box 58230
Karenpark
0118 Pretoria
SOUTH AFRICA
Tel: (0027) 12 3353663
Fax: (0027) 12 3356745
Email: jcmader@mweb.co.za

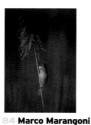

32 Daniel Magnin
Les Bruyères de Bouvier
71200 Saint Sernin Du Bois
FRANCE
Tel: (0033) 3 85 80 26 52
Email: d.magnin@libertysurf.fr
http://danielmagnin.free.fr

84 Marco Marangoni
Via Doschi Nuovi, 23
41030 Mirandola (MO)
ITALY
Tel: (0039) 0535 31402
Email: m.maranga@tin.it

102 Luiz Claudio Marigo
Rua General Glicério, 364/604
Laranjeiras
22245-120 Rio de Janeiro RJ
BRAZIL
Tel: (0055) 21 2285 4606
Fax: (0055) 21 2556 1832
Email: studio@lcmarigo.com.br
www.lcmarigo.com.br

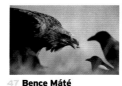

47 Bence Máté
2/b Mezö u
6769 Pusztaszer
HUNGARY
Tel: (0036) 20 4166002
Email: bence@matebence.hu
www.matebence.hu

Agent
Sam Zalányi
Tel: (0036) 30 5258295
Email: sam@matebence.hu

36 Scott McKinley
7250 South Highway 89 # 67
PO Box 1358
Jackson
WY 83001
USA
Tel: (001) 307 733 6818
Fax: (001) 307 733 6831
Email: srmfilms@aol.com
www.scottmckinleyproductions.com

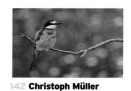

148 Olivia McMurray
PO Box 2128
1200 Nelspruit
Mpumalanga
SOUTH AFRICA
Tel: (0027) 13 750 3095
Fax: (0027) 13 750 2769
Email: bushbabyliv@webmail.co.za

104 Larry Michael
PO Box 498
12800 W. Silver Spring Drive
Butler
WI 53007
USA
Tel: (001) 414 581 3714
Fax: (001) 262 790 9009
Email: larry@brehmeragency.com
www.larrymichael.com

Agent
Nature Picture Library
BBC Broadcasting House
Whiteladies Road
Bristol BS8 2LR
UK
Tel: 0117 974 6720
Fax: 0117 923 8166
Email: info@naturepl.com
www.naturepl.com

142 Christoph Müller
Unterer Pustenberg 66
45239 Essen
GERMANY
Tel: (0049) 201 493585
Email: christophmue@onlinehome.de

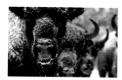

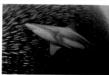

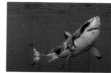

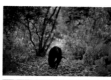

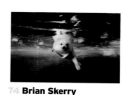

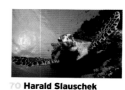

46 Josef Stefan
Hollenstein 40
3710 Ziersdorf
AUSTRIA
Tel: (0043) 6505 737 174
Fax: (0043) 2956 3350
Email: josefstefan@aon.at

61, 83 József L Szentpéteri
Kossuth u. 36
4024 Debrecen
HUNGARY
Tel: (0036) 70 214 9573
Fax: (0036) 52 310 752
Email: natura@mail.natura.hu
www.natura.hu

92 Jesper Tönning
Sondergade 12
Assentoft
8900 Randers
DENMARK
Tel: (0045) 86494748
Email: jespertoenning@mail.dk

82 Stefano Unterthiner
Via Trento 5
11027 St Vincent (Ao)
ITALY
Tel: (0039) 347 6951159
Email: info@stefanounterthiner.com
www.stefanounterthiner.com

128-138 Kobe Van Looveren
Wiezelo 61
2990 Wuustwezel
BELGIUM
Tel: (0032) 3 633 23 45
Fax: (0032) 3 663 32 41
Email:
kobe_van_looveren@hotmail.com

42, 108 Jan Vermeer
Planetenlaan 10
7314 KA Apeldoorn
THE NETHERLANDS
Tel: (0031) 55 3555 803
Fax: (0031) 55 3557 268
Email: janvermeer.foto@planet.nl
www.janvermeer.nl

Agent
Foto Natura
PO Box 134
1520 AC Wormerveer
THE NETHERLANDS
Tel: (0031) 75 640 1249
info@fotonatura.com
www.fotonatura.com

111 Hugo Wassermann
Schiessstand Strasse 3
39042 Brixen (BZ)
ITALY
Tel: (0039) 0472 833461
Email: hugo.wassermann@dnet.it

106 Ulf Westerberg
Bettys väg 42
230 43 Klagshamn
SWEDEN
Tel: (0046) 40 468014
Email: info@ulfwesterberg.com
www.ulfwesterberg.com

126 Terry Whittaker
c/o 46 Ormonde Road
Hythe
Kent CT21 6DW
UK
Tel: 07971 194115
Email:
terry.whittaker@btopenworld.com
www.terrywhittaker.com

Agents
FLPA
Pages Green House
Wetheringsett
Stowmarket
Suffolk IP14 5QA
UK
Tel: 01728 860789
Fax: 01728 860222
Email: pictures@flpa-images.co.uk
www.flpa-images.co.uk

Photo Researchers
60 East 56th Street
New York, NY 10022
Tel: (001) 212 758 3420
Fax: (001) 212 355 0731
Email: info@photoresearchers.com
www.photoresearchers.com

118 Staffan Widstrand
Smedvägen 5
176 71 Järfälla
SWEDEN
Tel: (0046) 70 657 33 24
Fax: (0046) 8 584 903 30
Email: photo@staffanwidstrand.se
www.staffanwidstrand.se

Agents
Nature Picture Library
BBC Broadcasting House
Whiteladies Road
Bristol BS8 2LR
UK
Tel: 0117 974 6720
Fax: 0117 923 8166
Email: info@naturepl.com
www.naturepl.com

Bruce Coleman, The Natural World
16 Chiltern Business Village
Arundel Road
Uxbridge UB8 2SN
UK
Tel: 01895 467990
Fax: 01895 467959
Email: library@brucecoleman.co.uk
www.brucecoleman.co.uk

Corbis
111 Salisbury Road
London NW6 6RG
UK
Tel: 0800 731 9995
Fax: 020 7644 7645
Email: info@corbis.com
www.corbis.com

Naturbild
Drottning. 73 B
Box 3353
103 67 Stockholm
SWEDEN
Tel: (0046) 8 411 43 30
Fax: (0046) 8 411 22 30
Email: info@naturbild.se
www.naturbild.se

16 Hans Wolkers
Warnaarlaan 60
2172 JA Sassenheim
THE NETHERLANDS
Tel: (0031) 252 212320
Email: hans.wolkers@npolar.no

56 Christian Ziegler
2315 W 6th Avenue, Suite 1
Vancouver BC
V6K1W1
CANADA
Email: zieglerphoto@yahoo.com
www.naturphoto.de